IRELAND'S
WESTERN ISLANDS

Inishbofin, The Aran Islands, Inishturk,
Inishark, Clare & Turbot Islands

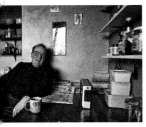 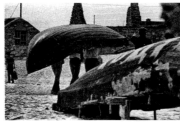 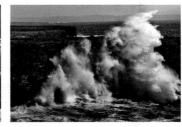 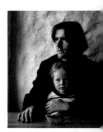

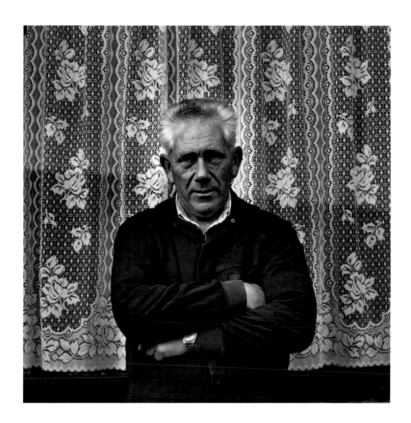

Pete Tierney, East End, Inishbofin

IRELAND'S
WESTERN ISLANDS

Inishbofin, The Aran Islands, Inishturk,
Inishark, Clare & Turbot Islands

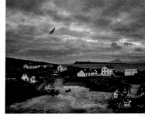

JOHN CARLOS

The Collins Press

For all Irish islanders, especially those who
were dispossessed of their homelands

In memory of my uncle, Gerald Glynn,
an Aran disciple and keen photographer

The book is dedicated to my mother, Emmie, who encouraged me to use her simple
Kodak camera during our visits to Inis Mór in the mid-1960s. Her regard for the islands
and their people inspired me to return to the islands one day to carry out this project.

FIRST PUBLISHED IN 2014 BY
The Collins Press
West Link Park
Doughcloyne
Wilton
Cork

Reprinted 2014

A CIP record for this book is available from the British Library.

ISBN: 978-1-84889-205-7

Design and typesetting by Fairways Design
Typeset in Minion Pro/New Aster
Printed in Poland by Białostockie Zakłady Graficzne SA

ACKNOWLEDGEMENTS

My appreciation and gratitude go primarily to the islanders in realising this project, for their trust, support and patience. These photographs are created from that experience, and of knowing a warm and hospitable people.

I am very grateful to Vincent Browne, my former Editor at the *Sunday Tribune*, for his generosity in providing me with time from the newspaper to work on the photographs.

To Margaret and the late Miko Day, Kieran Day and Theresa Ryan for their generosity, support and hospitality on Inishbofin, and also to the following for their warm hospitality: Mary Day Lavelle and Olive Day, both formerly of Day's Hotel; the Murray family at the Doonmore Hotel; the Coyne family, Dolphin Hotel; Caroline Coyne, the Galley and Orla Day and Adrian Herlihy at Day's Bar. My appreciation also goes to the following: Marie Coyne, Inishbofin Heritage Museum; Simon Murray and the Inishbofin Arts Festival Committee; Pat and Dermot Concannon of Island Discovery ferries, Inishbofin; O'Grady's and O'Malley's ferry companies who service Clare Island and Inishturk; Michael Joe O'Halloran, Inishbofin, and his brother, Martin, Inishturk; Mary Catherine and Bill Heanue, Inishturk; the late Delia Concannon, John Concannon and Mary-Jo Prendergast, Inishturk, and John and Mary Moran, Clare Island.

The memorial to the Kansas students on p. 86 was sculpted by John Behan and initiated by Margaret Day, Inishbofin. I am grateful to Bobby Molloy, when he was Minister for Defence, and the Irish Air Corps for their help with the photograph on p. 92. The Inishbofin map drawn by Kieran Concannon and produced by the Inishbofin Heritage Project was very helpful.

My appreciation and thanks go also to the following: Treasa Hernon Joyce, the late Bridget Hernon and the staff at Kilmurvey House, Inis Mór (it was at this fine guesthouse that I first developed my interest in photography). To the staff of the Dún Aonghasa Heritage Centre, Kilmurvey, Inis Mór; Mick and Barbara O'Connell, Inis Mór; the staff and crews of Aran Island Ferries; the Aer Arann crews and ground staff including Michael and Peggy Hernon, Inis Mór; Rúairí Ó Conghaile, Tigh Rúairí and Johnny and Úna Mc Donagh, Inis Oírr.

Some place names were gleaned from the *Folding Landscapes* map, Oileáin Árann by Tim Robinson. I also consulted Richard Scott's book, *The Galway Hookers*, for caption information for the photograph on p. 200.

Thank you to Joe O'Shaughnessy and Billy Stickland for your goodwill and support; to Dave O'Connell, Group Editor and David Hickey, Group CEO, *The Connacht Tribune*, Galway, whose newspaper published photographs from the early Aran and Inishbofin work; to Gordon Standing of *The Irish Times*, for publishing the early Aran photographs; to Letitia Pollard, former editor of *Ireland of the Welcomes,* and Sonya Perkins, former editor-in-chief of *The World of Hibernia*, for publishing selections of the Inishbofin photographs. A selection of the Inishbofin work also appeared in *Inishbofin and Inishark*, published by James Morrissey, Crannóg Books. I am grateful to Jonathan Williams and Gerry Dawe for their contribution in

the initial days of the project. Thank you to Sharon Duffy of the Davitt Photo Centre, Salthill, Galway, who produced the work-prints for the project. A special thanks to my publishers, The Collins Press, for bringing this project to fruition.

I also pay special tribute to the inspiring collaborative works of author and storyteller John Berger and Jean Mohr and also the photography of Paul Strand.

John Carlos

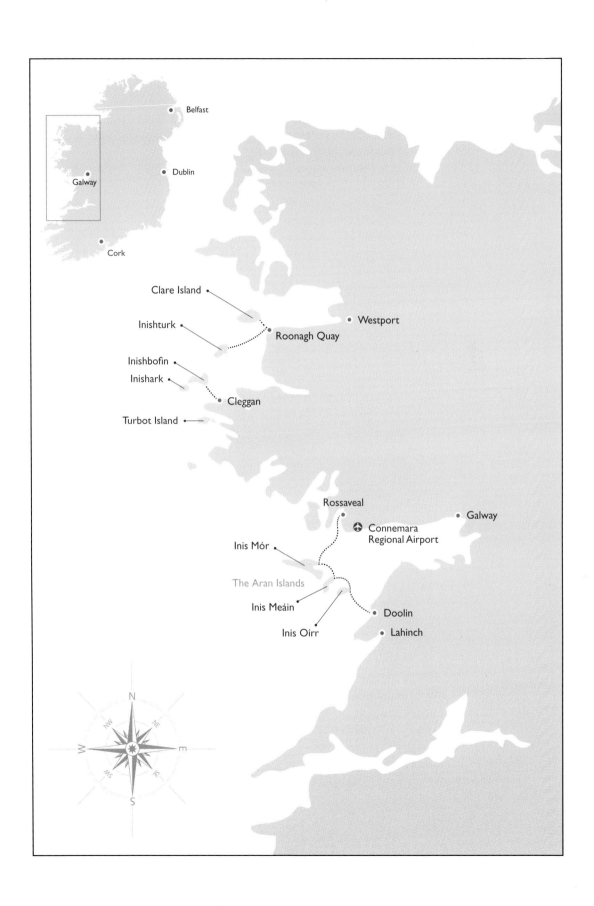

INTRODUCTION

This book is a celebration of the islanders of Inishbofin and the Aran Islands: Inis Mór, Inis Meáin and Inis Oírr, County Galway. It includes the islands of Inishturk and Clare Island, County Mayo, and also honours the people of Inishark and Turbot Island, County Galway, who were evacuated from their islands by the Irish government in 1960 and 1978 respectively.

The work reflects on disappearing traditions and culture in a society increasingly consumed by materialism, information technology and celebrity culture.

The sequences, which suggest a form of narration, draw on many elements to create a unity of opposites: people, wild flowers, youth, landscapes, home, religious icons, work, seascapes, animals, fish, rocks, love and loss. People and nature are intricately woven to portray their relationship with the islands, and the complexity of their lives therein.

The book is not an attempt in any way to define the islands or their people, but rather, to preserve a memory of the islanders and their homelands. Although the work spans almost fifty years, the photographs barely touch the surface of such a rich and diverse culture.

The population of our offshore islands has dwindled from 35,000 in the 1800s to fewer than 3,000 today. Between the 1950s and 1970s, several communities off the western seaboard were displaced from their islands, resulting in the destruction of their culture and identity.

The lack of adequate investment in employment incentives, even during our economically buoyant times, has drained the population on islands such as Inishturk. In 1985 there were thirty pupils in the island's National school; in 2014 there were three.

There are few temples or shrines honouring Irish islanders. There are, however, a myriad of memorials dedicated to their folk and fishermen lost at sea.

Apart from earlier visits to Inishbofin since 1976, the main thrust of the work was undertaken there and on the surrounding islands from 1992 until 2011. The photographs in Aran were made at various intervals from 1965 until 2013.

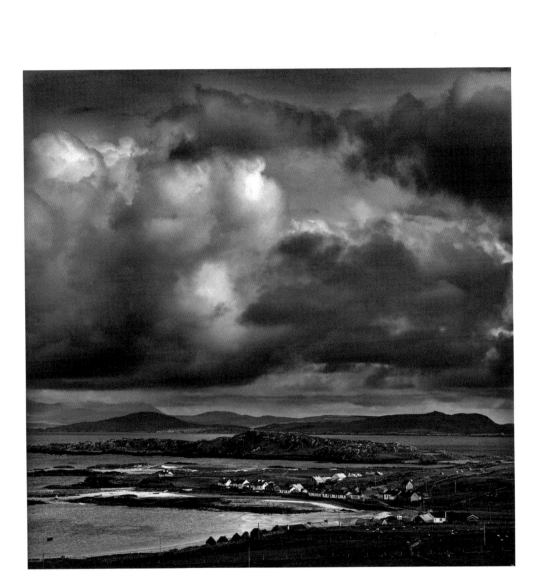

East End village, Inishbofin

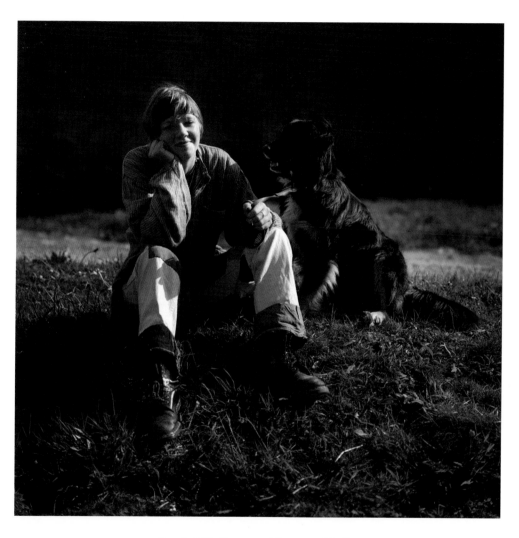

Bernie O'Halloran and Síog, Inishbofin

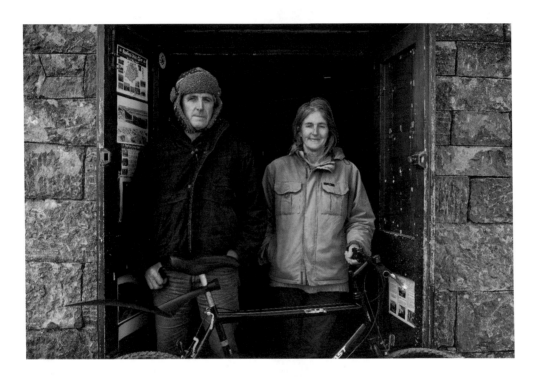

Michael Ó Conghaile and his sister, Sarah Crowe, Inis Oírr, Aran

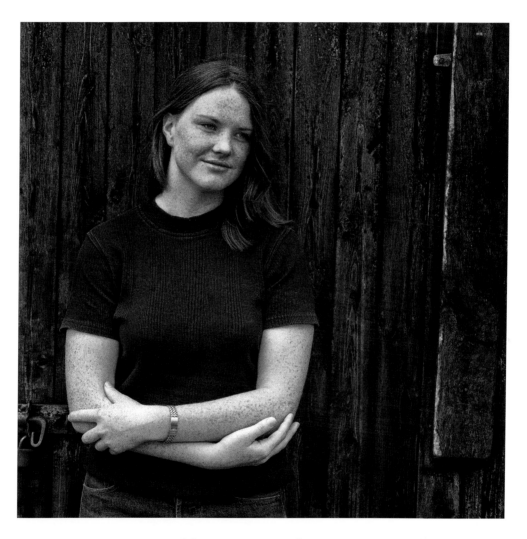

Maeve Flaherty, Gort na gCapall, Inis Mór, Aran

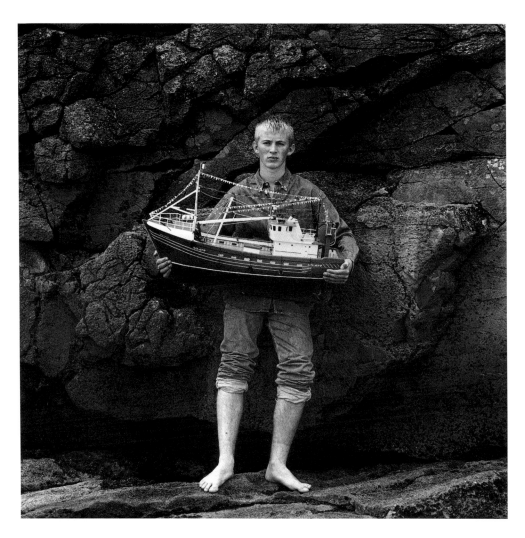

Máirtín Éanna Conneely with the replica he made of his father's trawler,
Iúda Naofa, *Sruthán, Inis Mór, Aran*

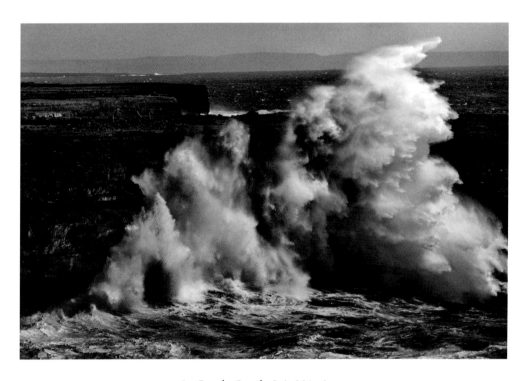

An Sunda Caoch, Inis Mór, Aran

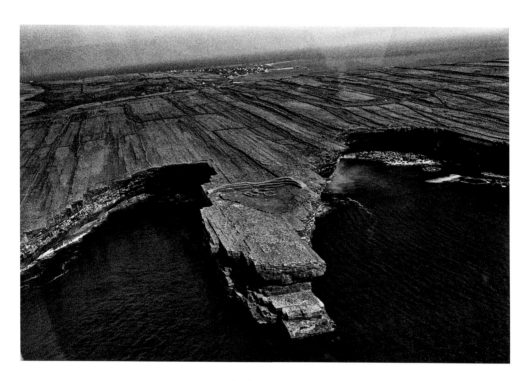

Dún Dúchathair, Inis Mór, Aran

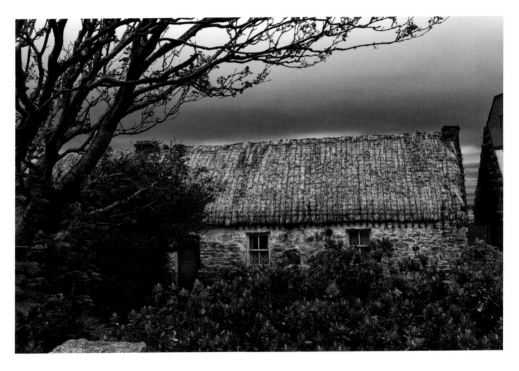

Teach Synge, Inis Meáin, Aran: a museum dedicated to the life and work of the celebrated playwright John Millington Synge

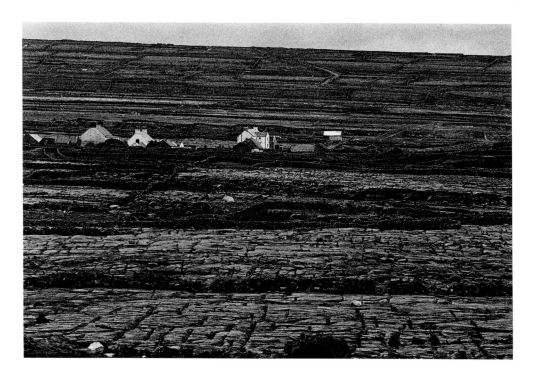

Gort na gCapall village, Inis Mór, Aran

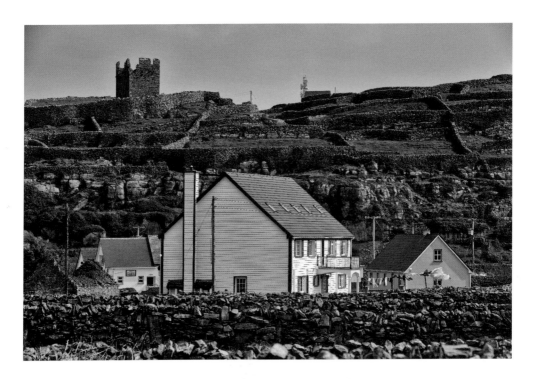

The Shamrock guesthouse and Dún Formna castle, Inis Oírr, Aran

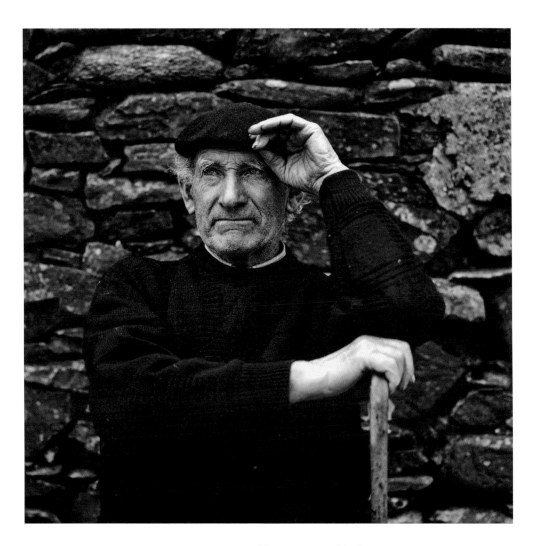

Owen Coyne, Middlequarter, Inishbofin

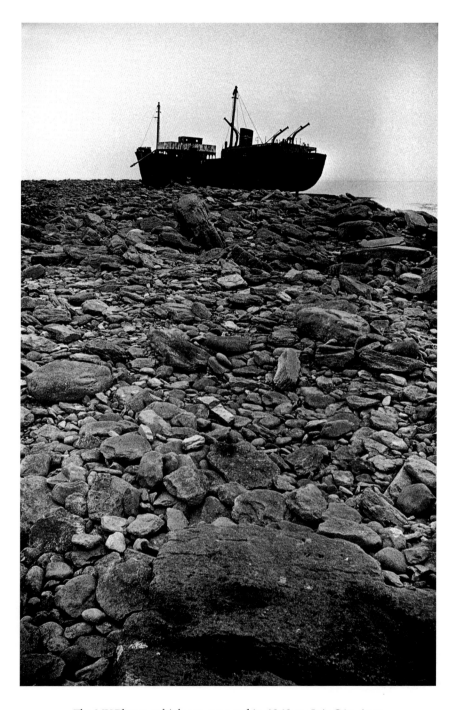

The MV Plassy, which ran aground in 1960 on Inis Oírr, Aran

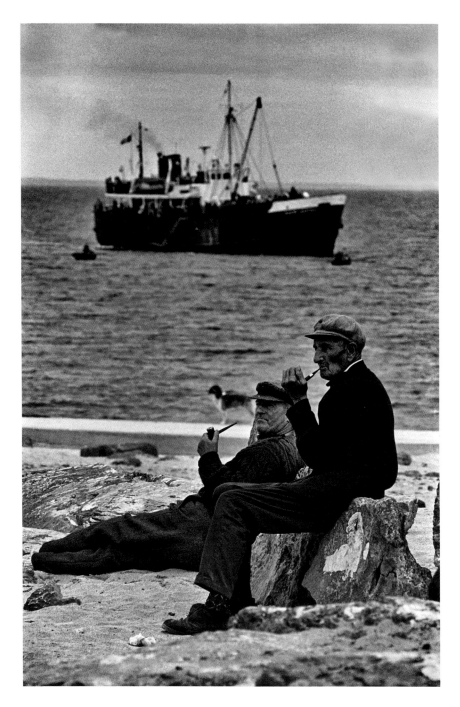

The Naomh Éanna *ferry at Inis Oírr, Aran*

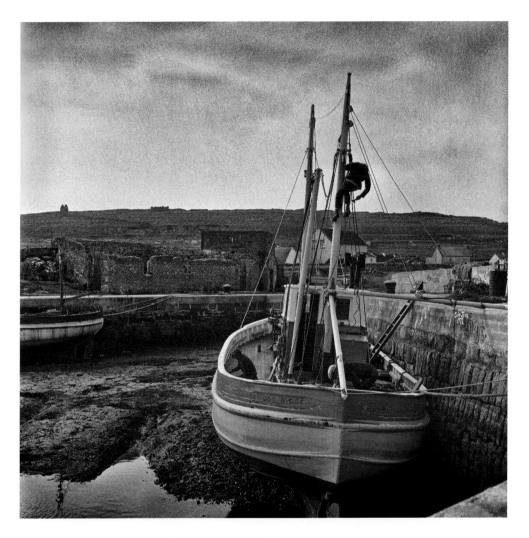

Ros Éinne *trawler in Cill Éinne, Inis Mór, Aran*

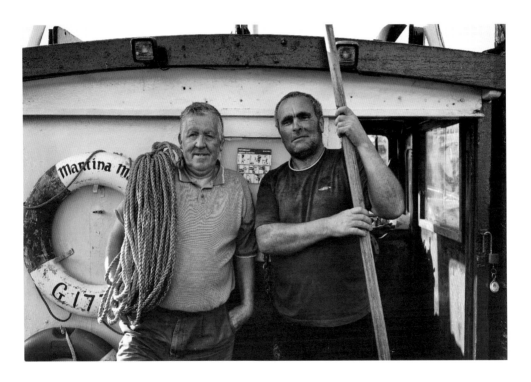

(L-r): Bill Heanue and Martin O'Halloran, Inishturk

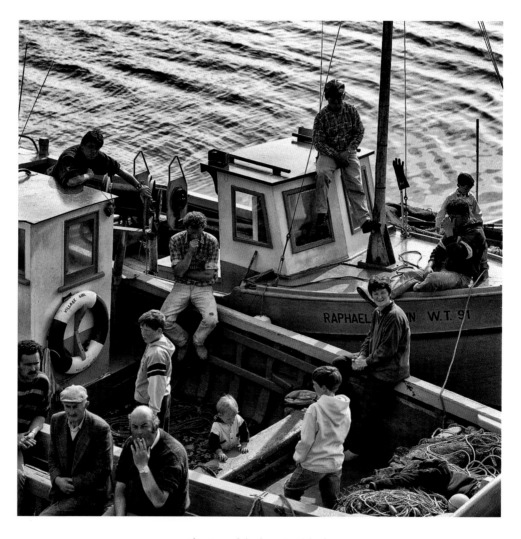

Blessing of the bay, Inishbofin

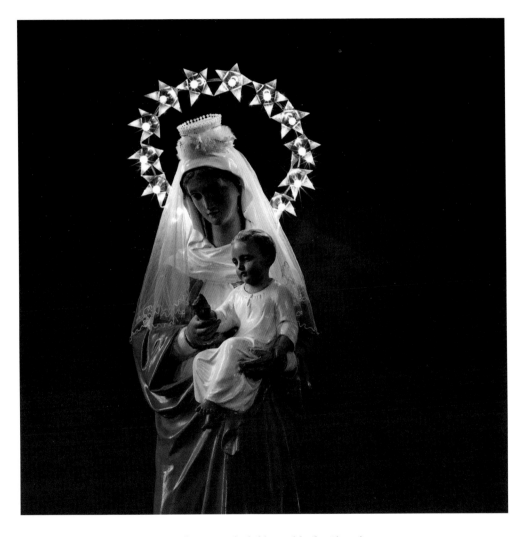

Madonna and Child, Inishbofin Church

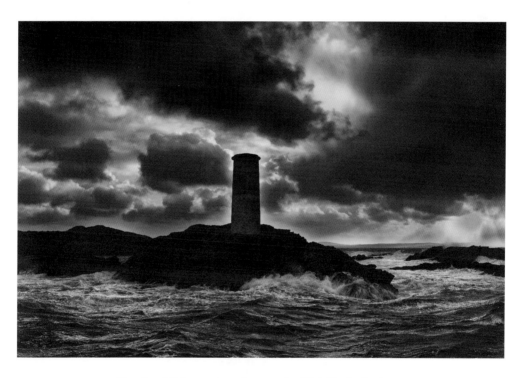

The signal light tower at the mouth of Inishbofin harbour

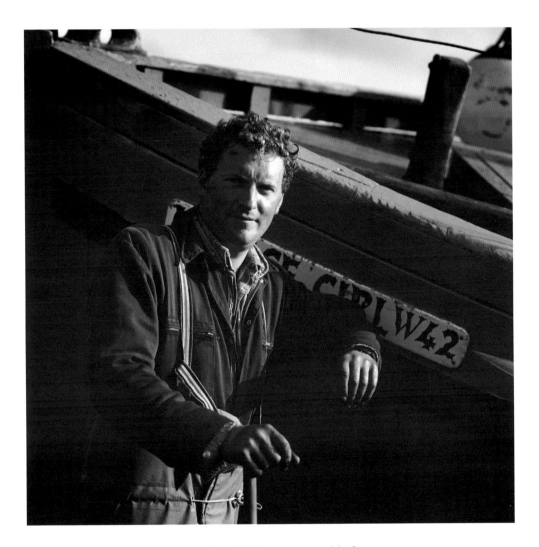

John Day, Middlequarter, Inishbofin

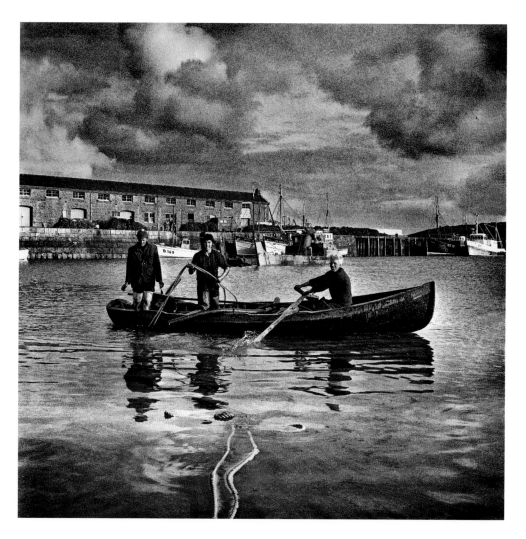

Kilronan harbour, Inis Mór, Aran

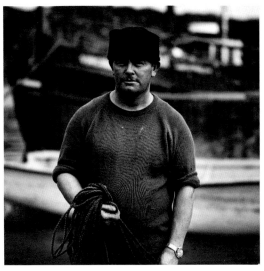

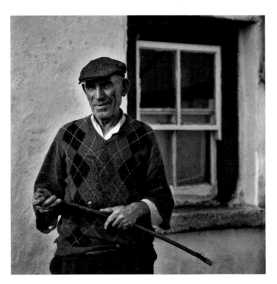

Gerry Moran, Inishbofin　　　　　*Thomas Cunnane, Inishbofin*

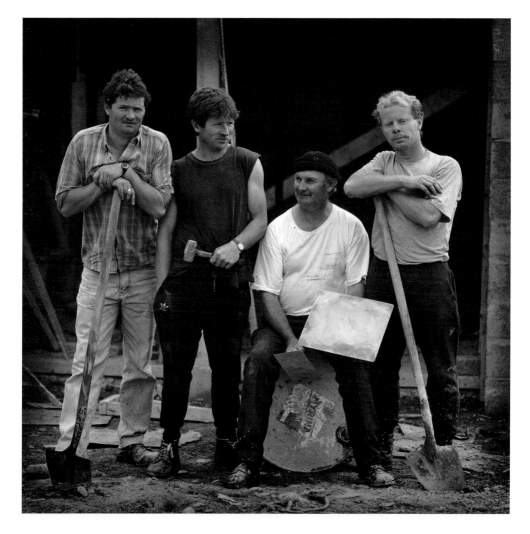

(L-r): Francis Day, Máirtín Lavelle, George Lacey and Enda Concannon, Inishbofin

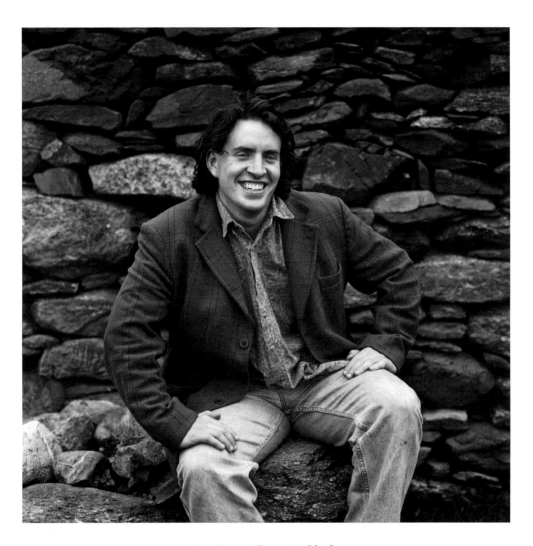

Pat Coyne, Clossy, Inishbofin

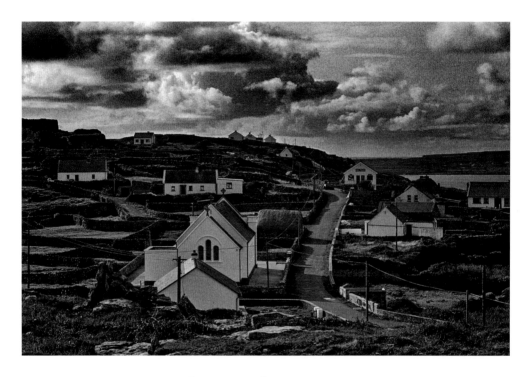

Baile an Teampaill, Inis Meáin, Aran

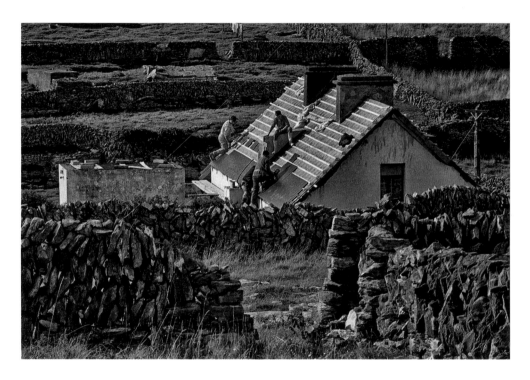

Roofing a house, Inis Meáin, Aran

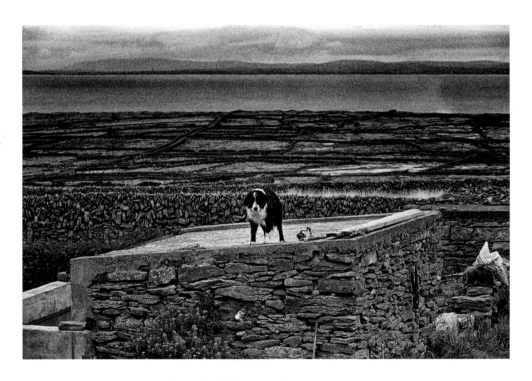

Relegated to the farm shed, Inis Meáin, Aran

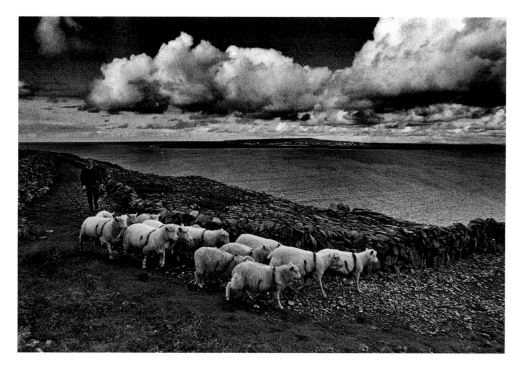

Herding sheep, Inis Meáin, Aran

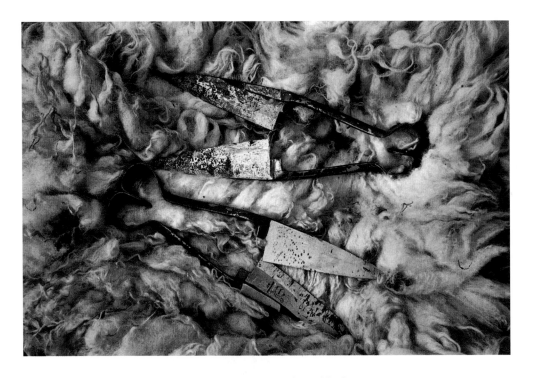

Sheep shears and wool, Inishbofin

Simon Murray, North Beach, Inishbofin

Ann Day, Fawnmore, Inishbofin

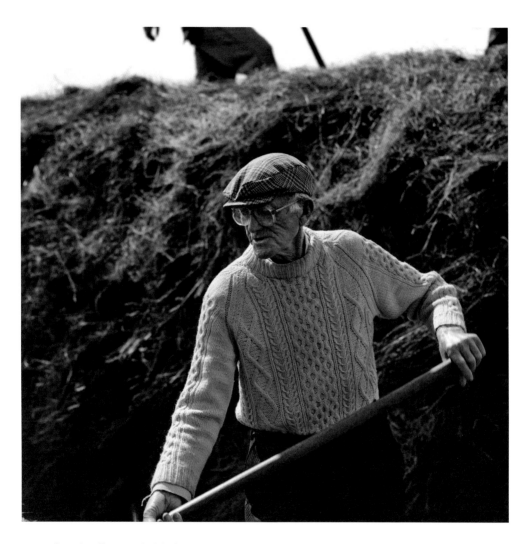

John O'Halloran, Claddaghduff, Connemara, reeking the hay on Coyne's farm, Inishbofin

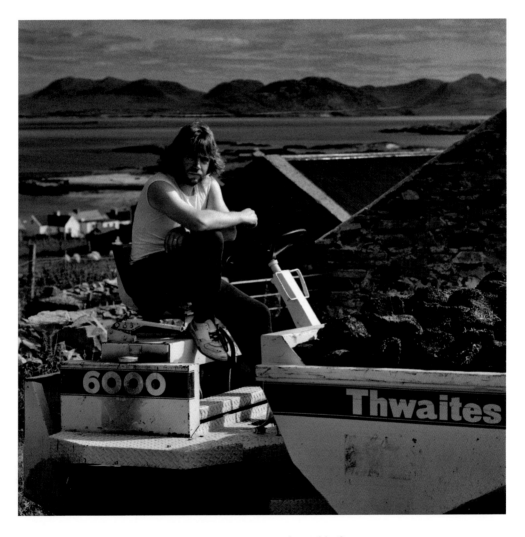

Henry Kenny, East End, Inishbofin

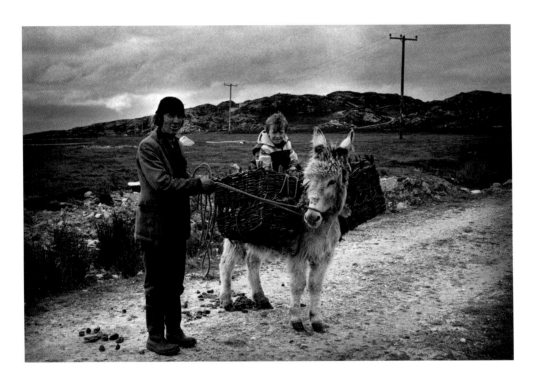

Jarleth Ward and his nephew John Ward, Inishbofin

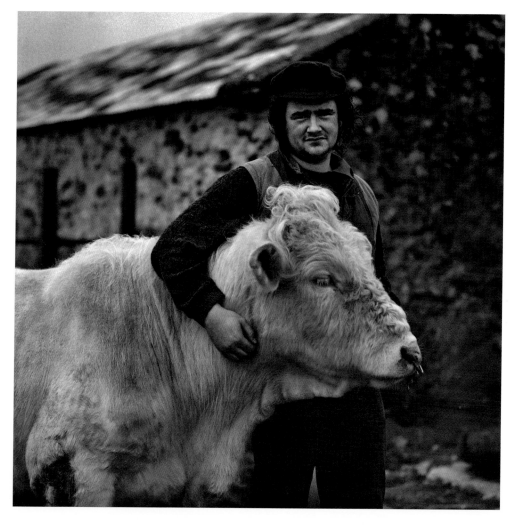

Tommy Burke and Louisburgh Fergal 1st, Inishbofin

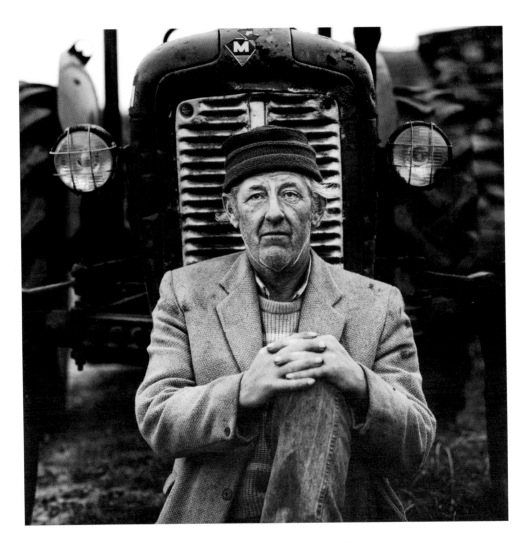

Andrew Concannon, Fawnmore, Inishbofin

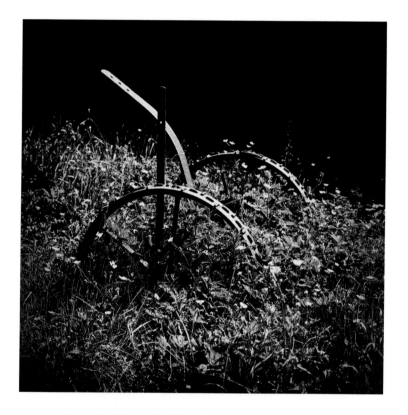

Sonny's old hay rake, Kilmurvey House, Inis Mór, Aran

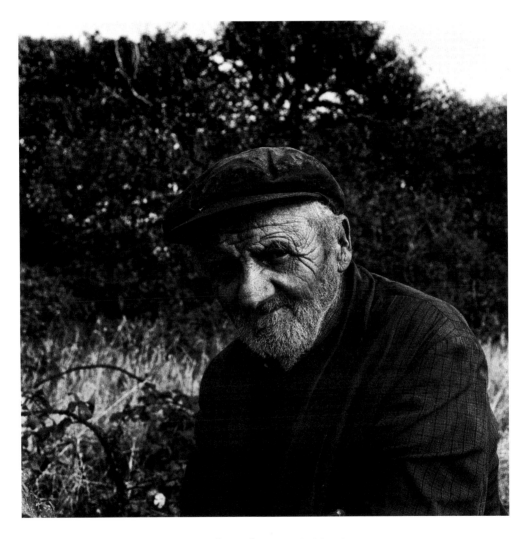

James Folan, Kilronan, Inis Mór, Aran

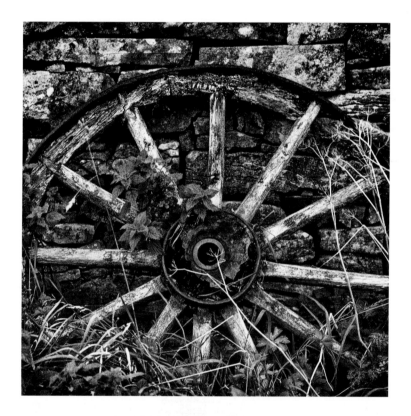

Cartwheel, Kilnurvey, Inis Mór, Aran

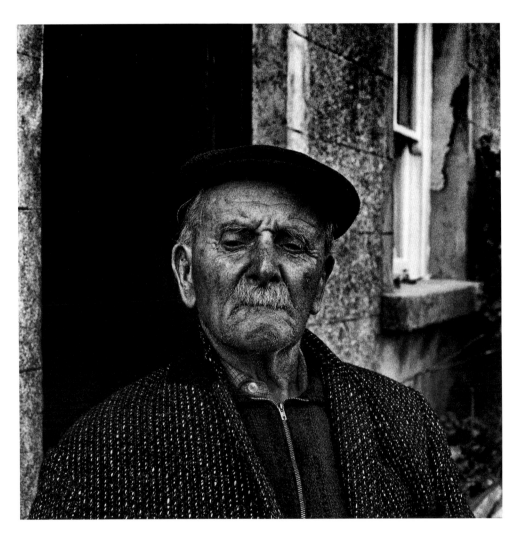

Bartley Gill, Kilronan, Inis Mór, Aran

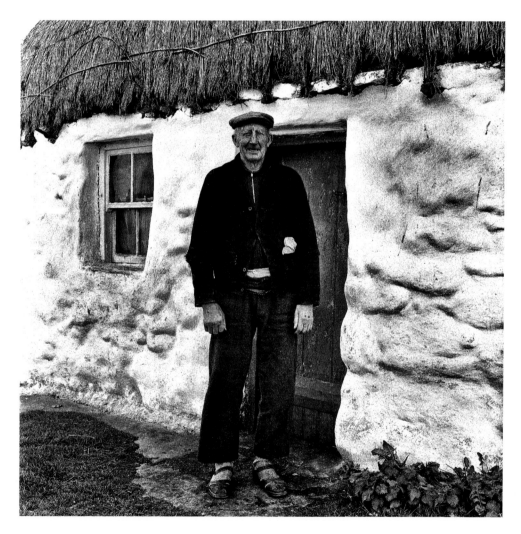

Mac Phait Sheáin Ó Conghaile, Creig a Chéirín, Inis Mór, Aran

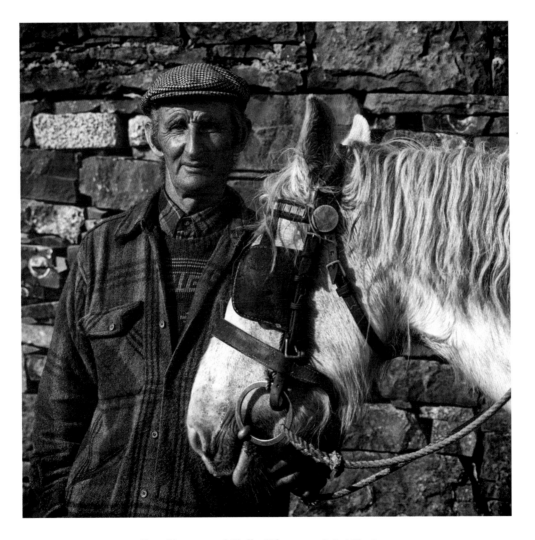

Tom Hernon and Molly, Kilmurvey, Inis Mór, Aran

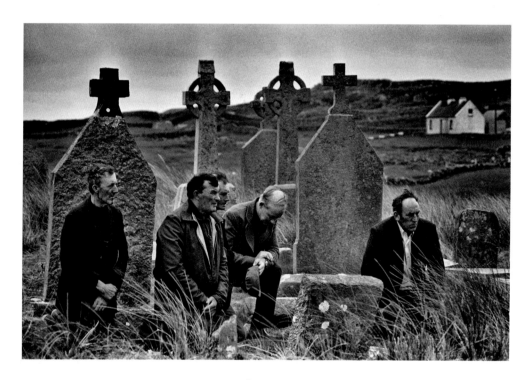

Funeral, Cill Éinne, Inis Mór, Aran

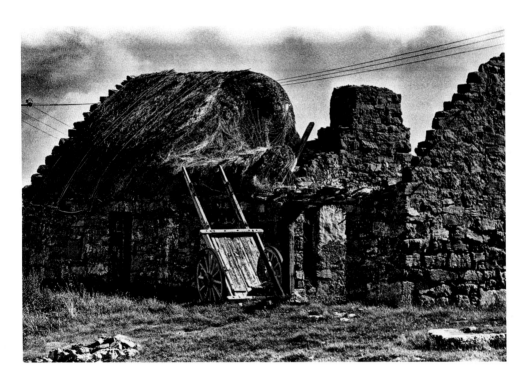

Horse cart and cottage ruin, Inis Mór, Aran

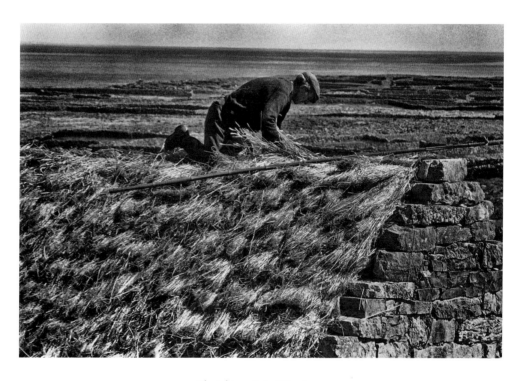

Thatching, Inis Mór, Aran

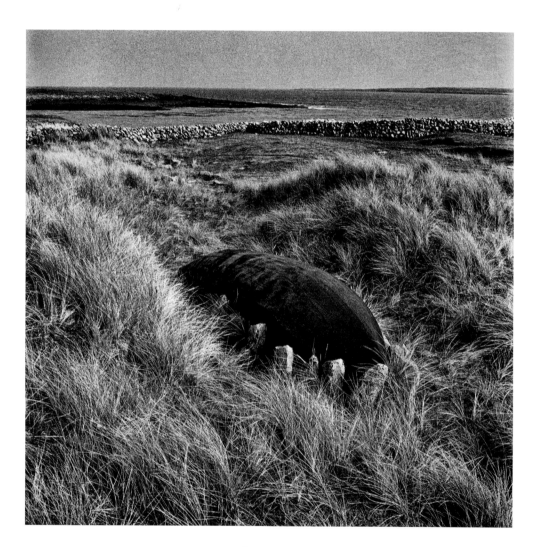

Currach, Inis Mór, Aran

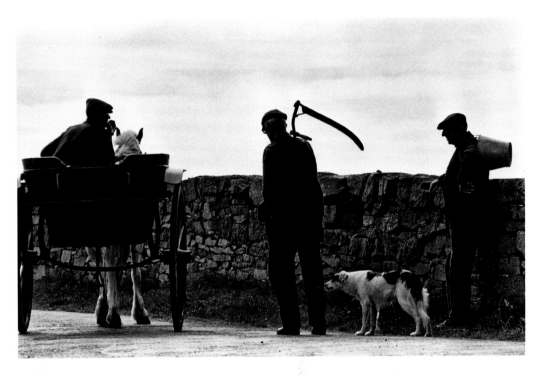

Rendezvous at Kilmurvey as Aran men make their way to work on Inis Mór

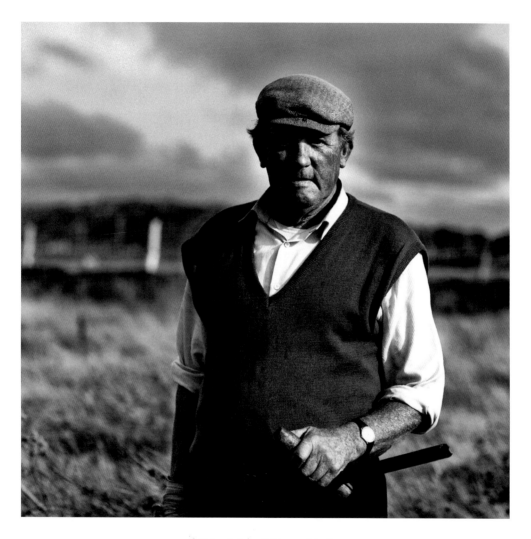

Michael Schofield, Inishbofin

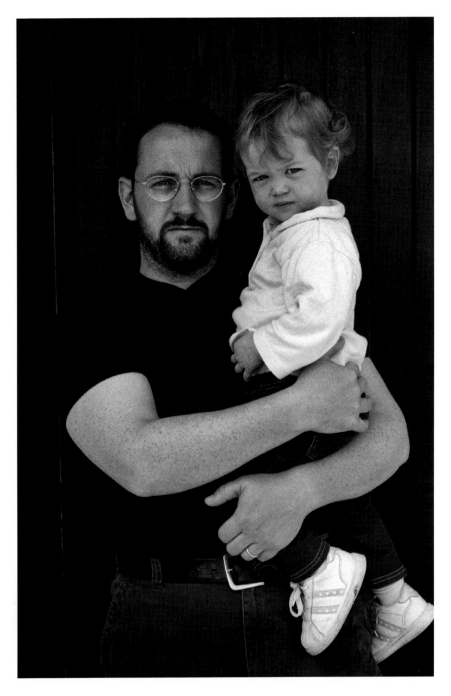

James Coyne and his daughter, Maeve, Inishbofin

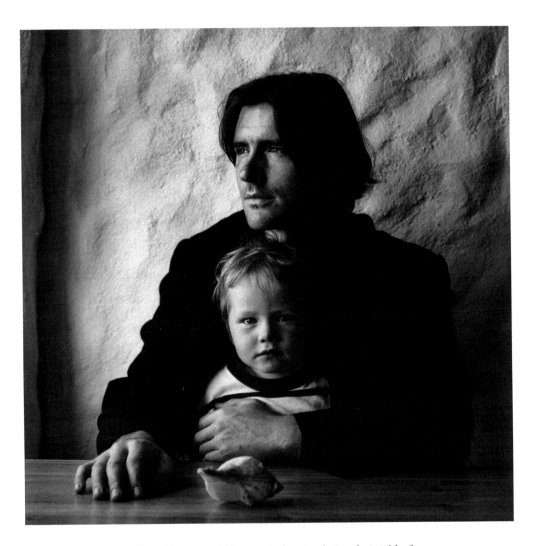

Andrew Murray and his son, Luke, North Beach, Inishbofin

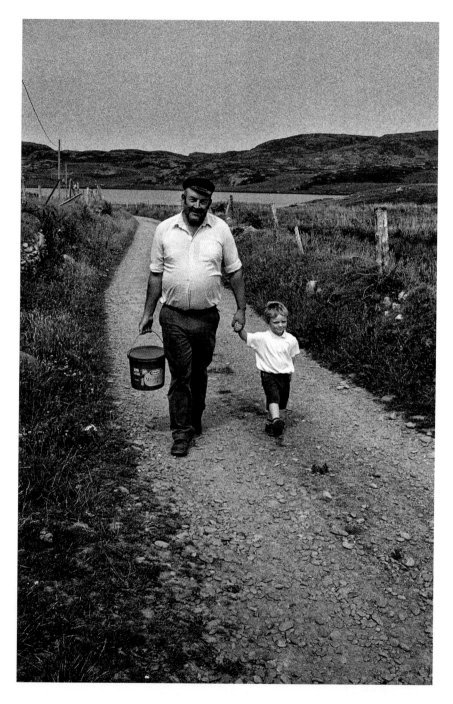

Michael Joe O'Halloran and his nephew, Shane Prendergast, Inishbofin

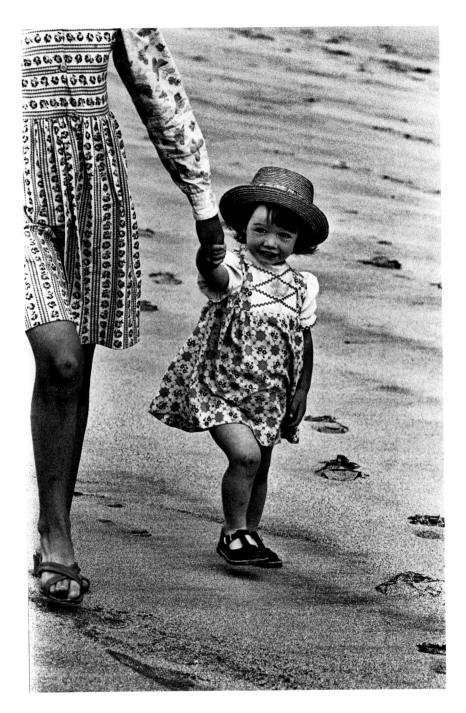

On the beach, Inis Oírr, Aran

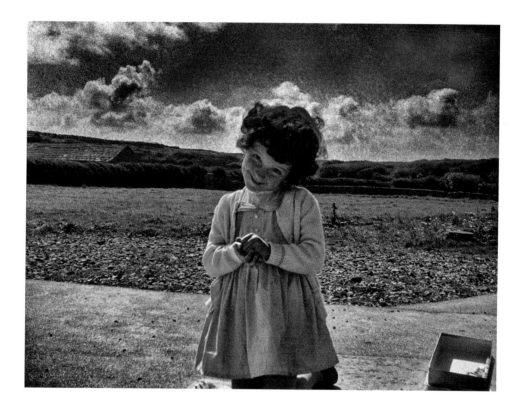

Treasa Hernon, Kilmurvey, Inis Mór, Aran

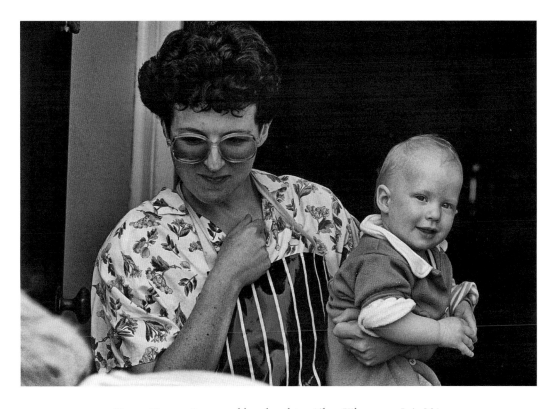

Treasa Hernon Joyce and her daughter, Ailsa, Kilmurvey, Inis Mór

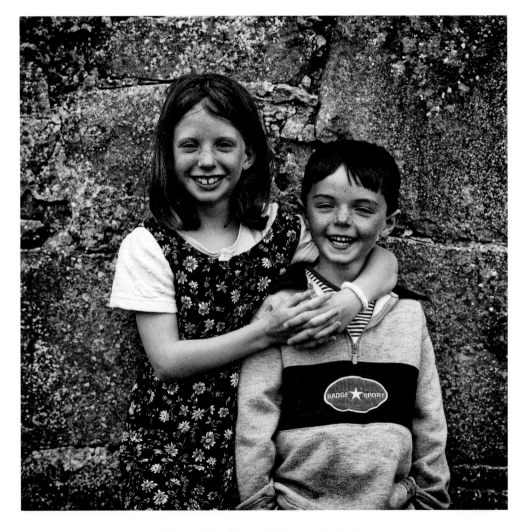

Ailsa and Noel Joyce, Kilmurvey, Inis Mór

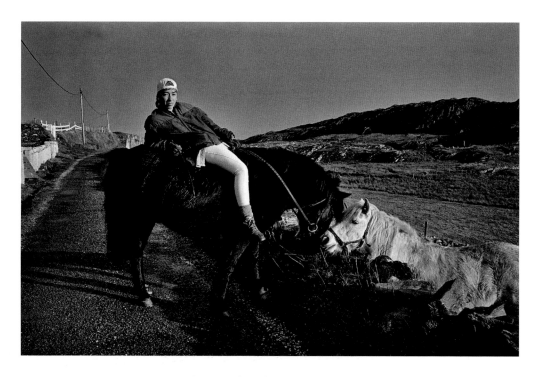

Teresa Abeyta with Sailor and Genie, Inishbofin

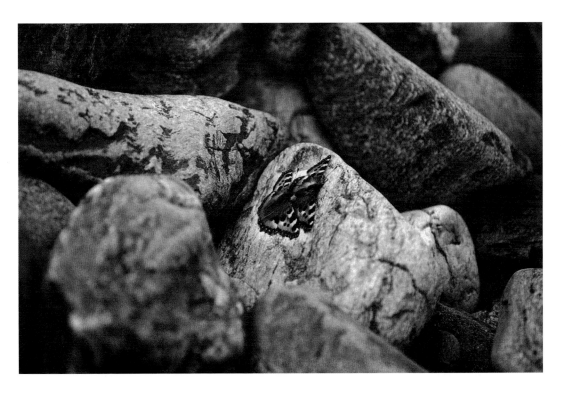

Tortoiseshell butterflies, Inishbofin

Pat Concannon and Nikola Jones, Low Road, Inishbofin

The living room, Kilmurvey House, Inis Mór, Aran

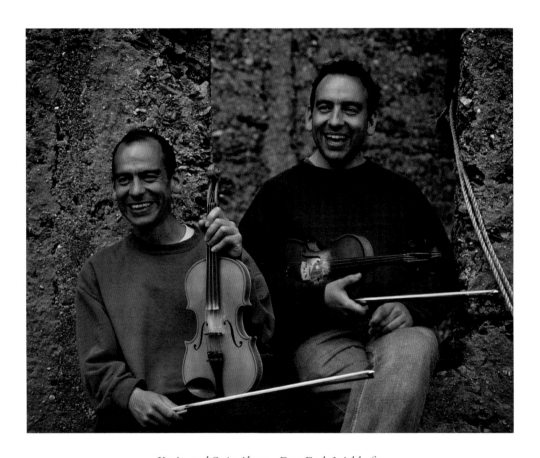

Kevin and Seán Abeyta, East End, Inishbofin

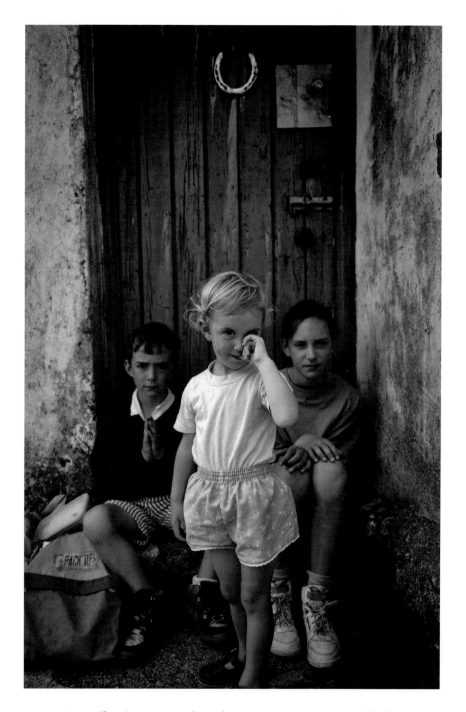

Tazzie (front), Aengus and Caroline Murray, Fawnmore, Inishbofin

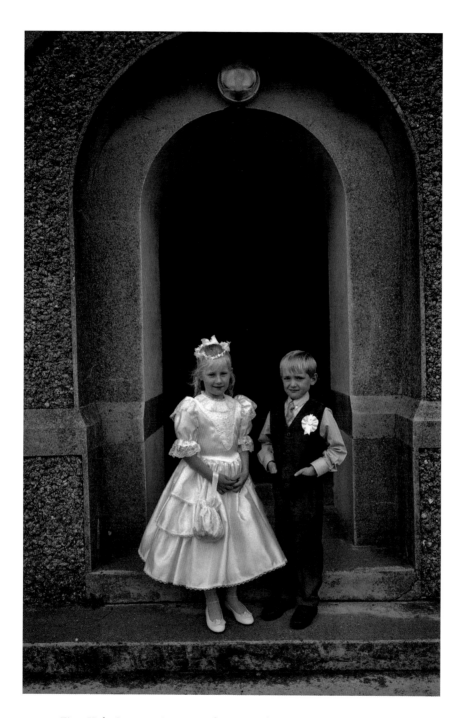

First Holy Communicants Aoife King and Simon Cloonan, Inisbofin

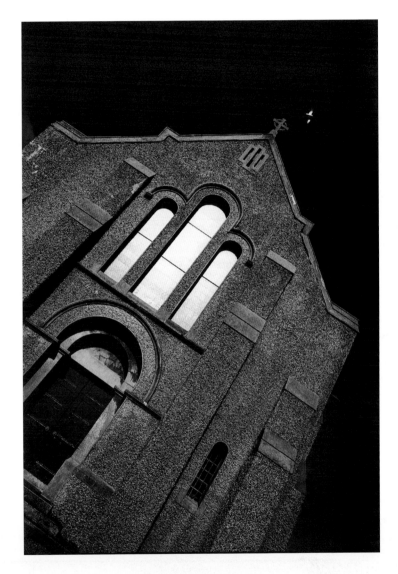

The church, Inishbofin

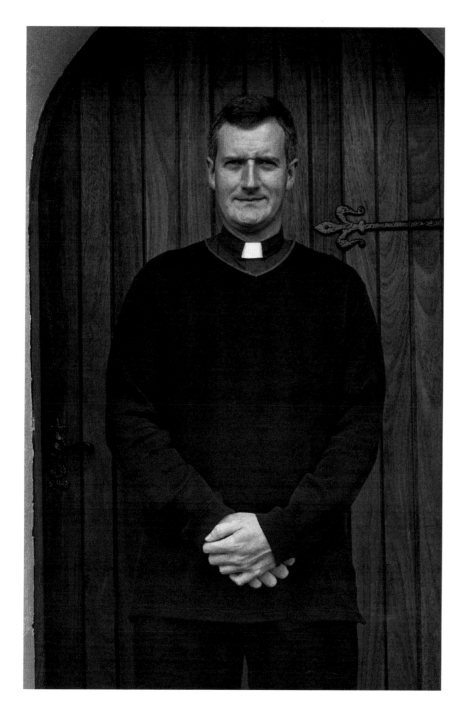

*Fr Declan Carroll, the last full-time priest on Inishbofin, pictured before
he departed from the island in 2001*

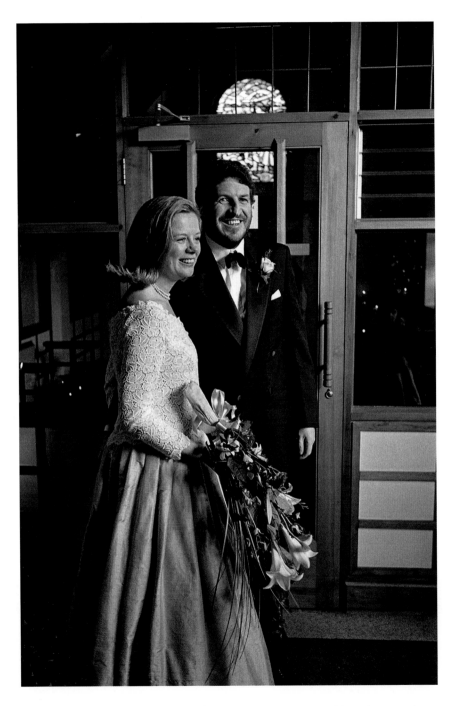

Kieran Day and Theresa Ryan, Clossy, Inishbofin, on their wedding day in Galway

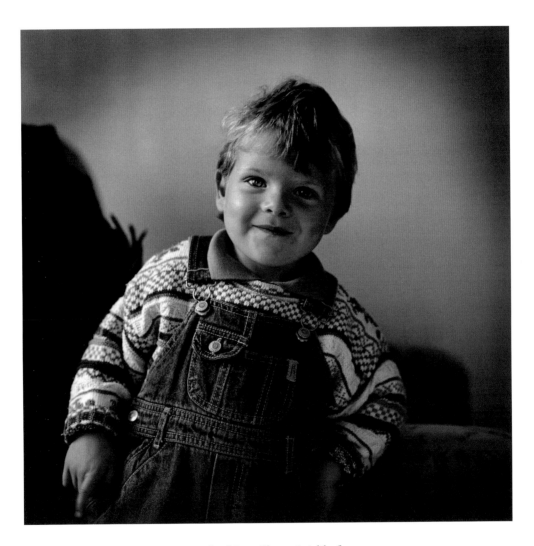

Michael Day, Clossy, Inishbofin

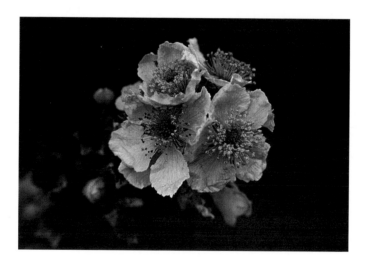

Blackberry flower, Inishbofin

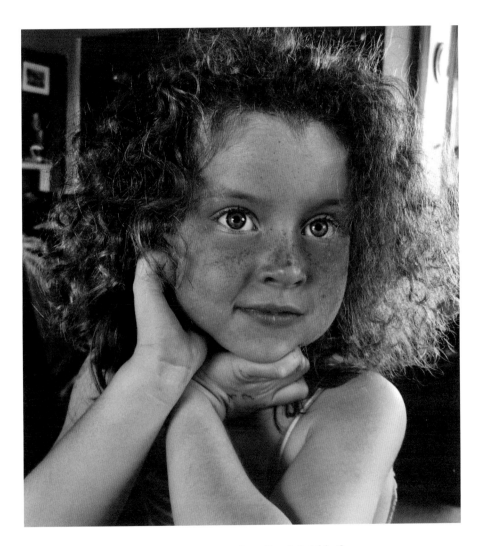

Kitty Concannon, Low Road, Inishbofin

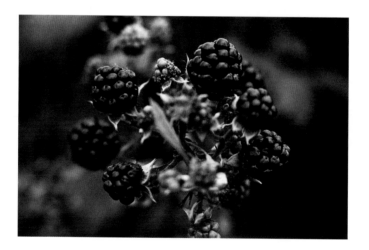

Blackberry fruit, Inishbofin

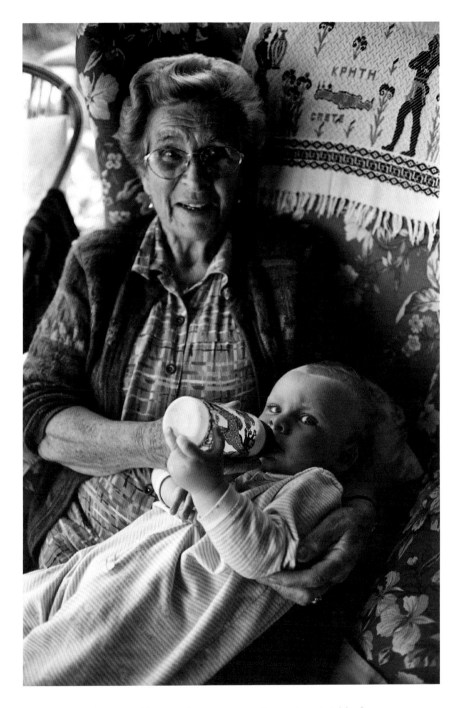

Margaret Day and her grandson, Conor Day, Inishbofin

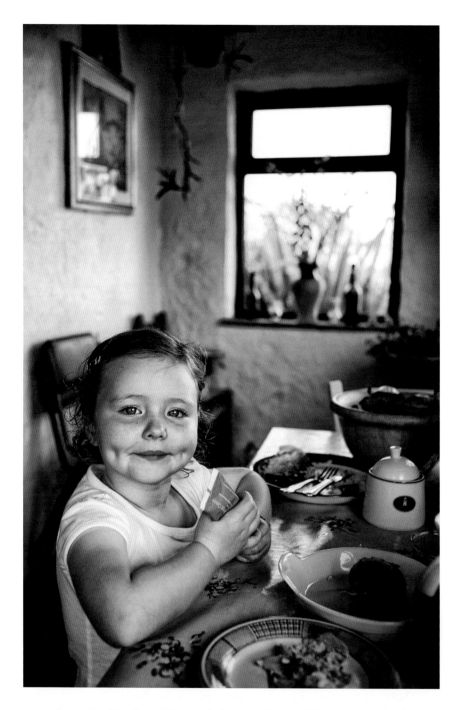

Laura Hopkins from Westport in her grandparents' house on Inishturk

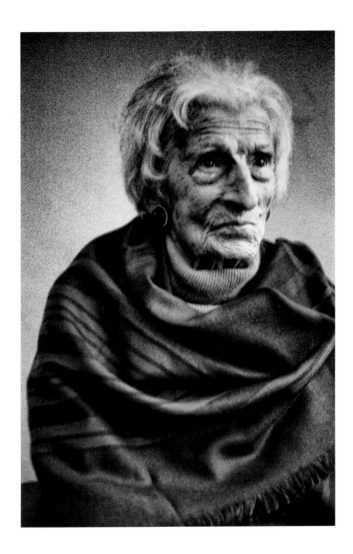

Bridget Dirrane, Inis Mór, at 106 years. A member of Cumann na mBan, the republican women's organisation, she went on hunger strike when in Mountjoy Jail. She became a nurse in the early 1900s and after her arrest while on duty in the Dublin home of a nationalist sympathiser, she infuriated the police at the Bridewell station by dancing and singing in Irish. She married an Aran Islander, Ned Dirrane, in Boston, where she joined the Democratic Party and campaigned for John F. Kennedy. She drove a Chevrolet Bel Air to cover her nationwide nursing assignments while in the US. After Ned died, she returned to Aran and married his brother, Patrick. When he in turn died, she had her two wedding rings bonded together. Bridget died on New Year's Eve 2003 at the age of 109.

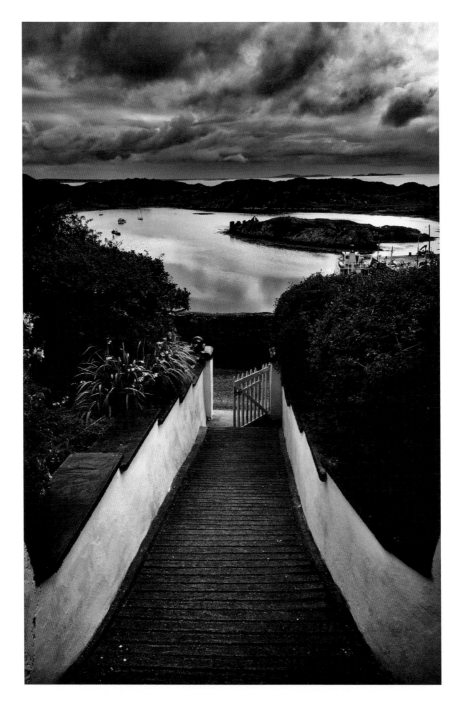

Inishbofin harbour as seen from Eileen Coyne's home

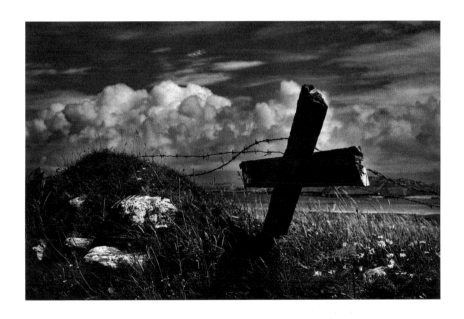

Fence post, Dumhach, Inishbofin

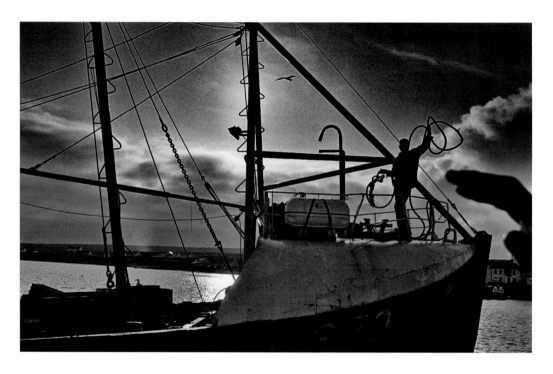

Kilronan harbour, Inis Mór, Aran

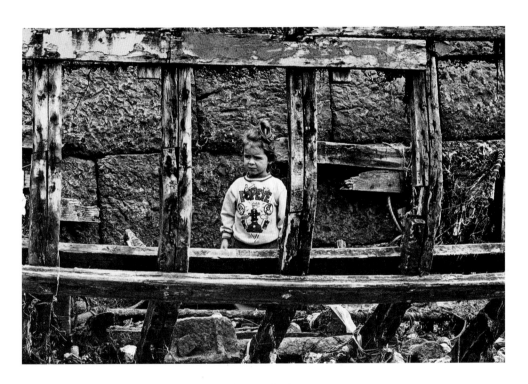

Trawler skeleton, Kilronan harbour, Inis Mór, Aran

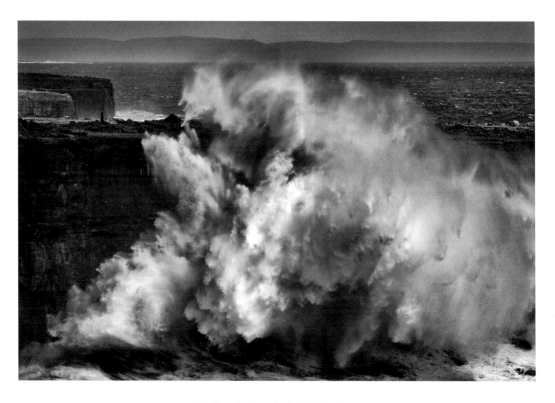

An Sunda Caoch, Inis Mór, Aran

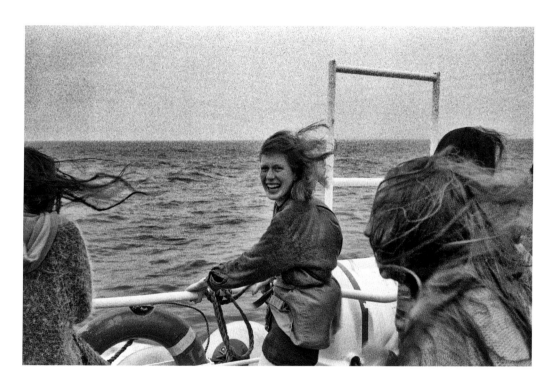

Tourists sailing to Inis Mór, Aran

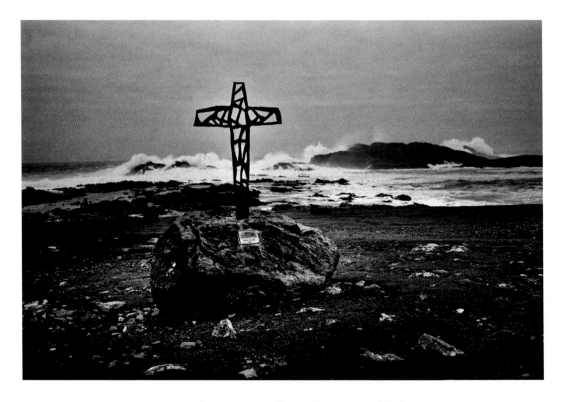

Memorial to Kansas students, the Stags, Inishbofin

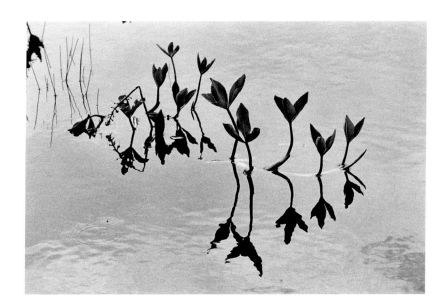

Bog-water plant, Inishbofin

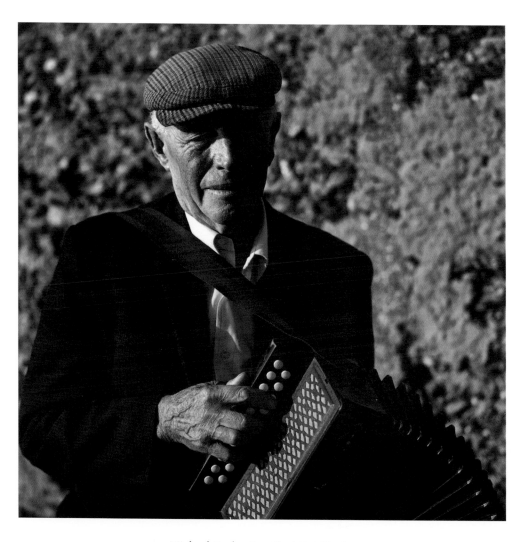

Michael Burke, East End, Inishbofin

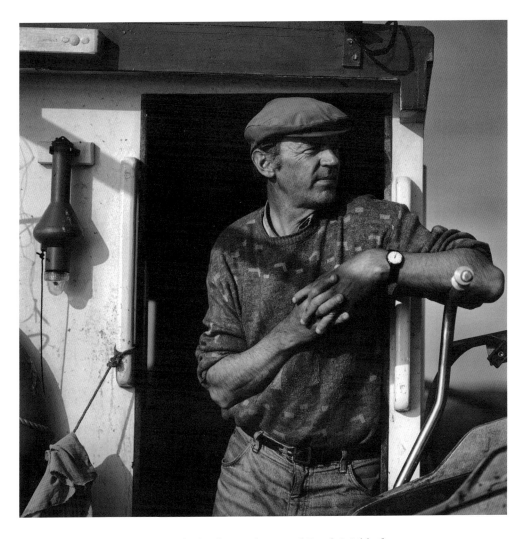

Desmond O'Halloran, the Pound Road, Inishbofin

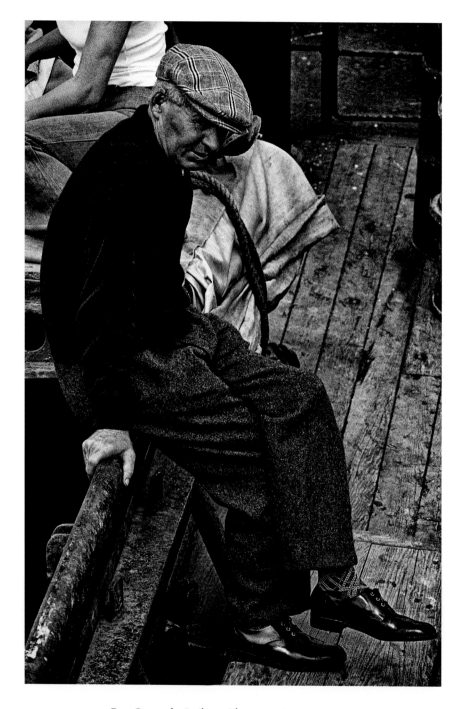

Pete Conneely, Baile an Fhormna, Inis Oírr, Aran

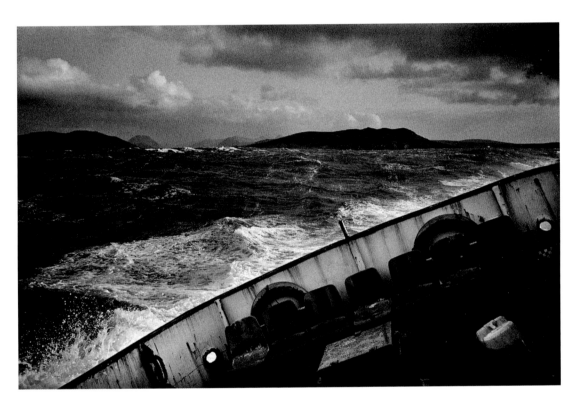

The Dún Aengus *ferry sailing to Inishbofin*

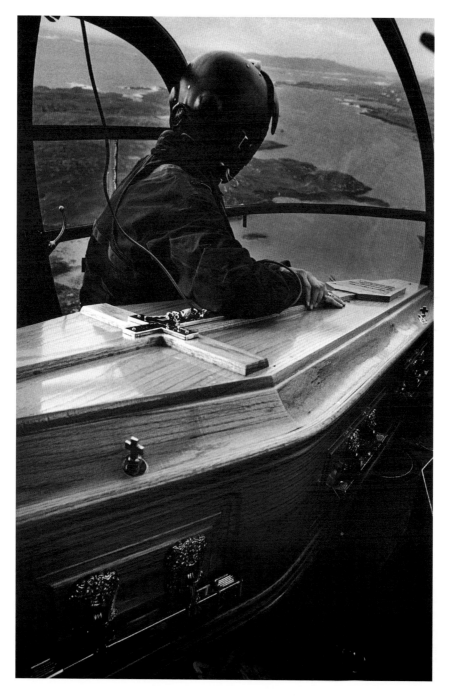

*The remains of Pete Burke being airlifted by helicopter during
rough seas to Inishbofin*

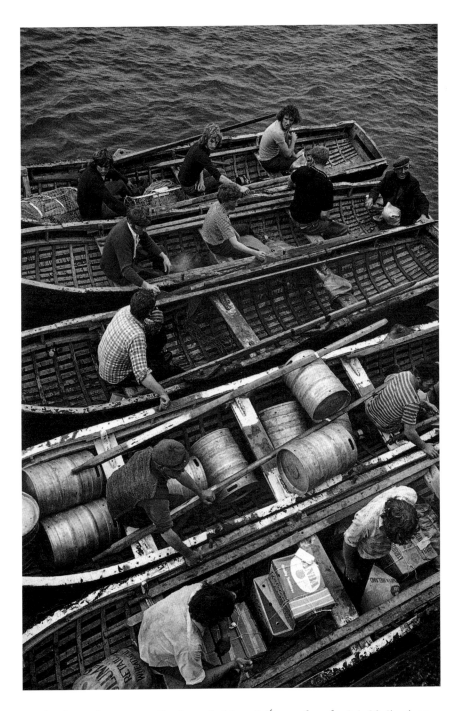

Islanders collecting supplies from the Naomh Éanna *ferry for Inis Meáin, Aran*

Rock art, Inis Mór, Aran

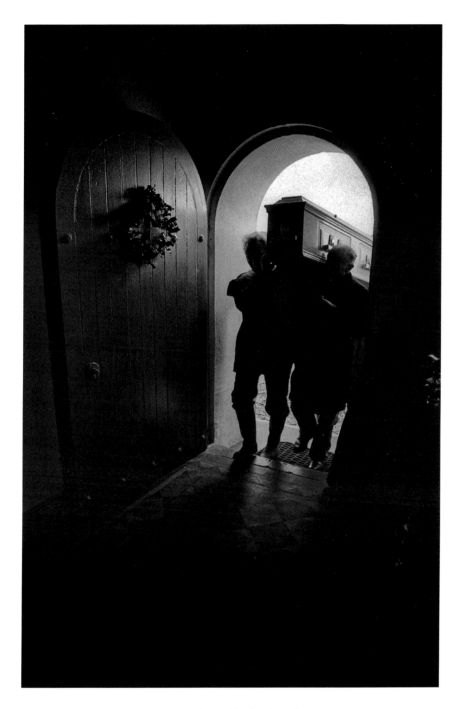

Funeral, Inishbofin church

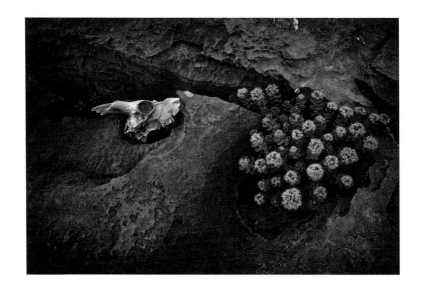

Sheep skull, limestone and flora, Inis Mór, Aran

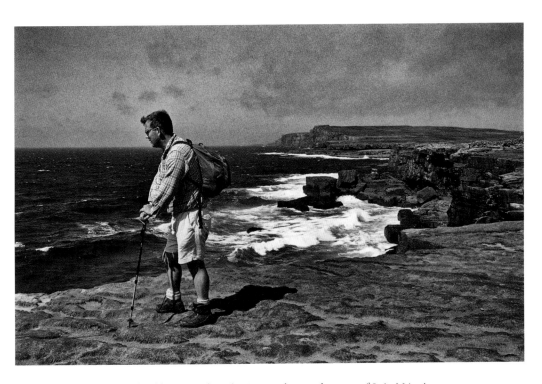

Michael Gibbons, archaeologist, on the south coast of Inis Mór, Aran

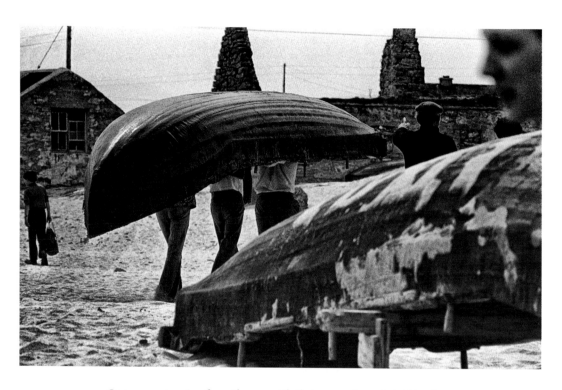

Oarsmen returning from the sea with their currach on Inis Oírr, Aran

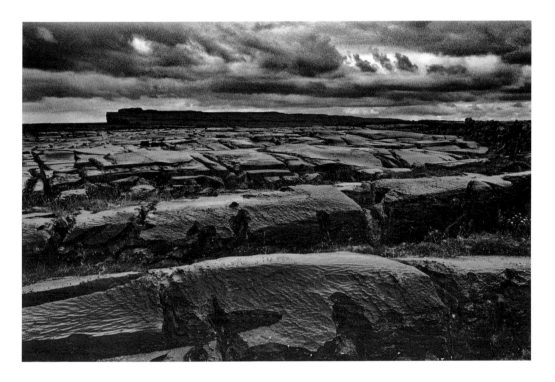

Limestone terraces, Gort na gCapall, Inis Mór, Aran

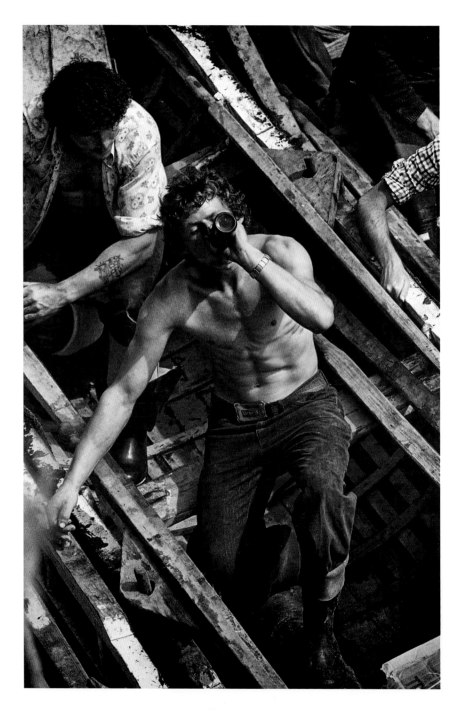

Waiting for the ferry, Aran

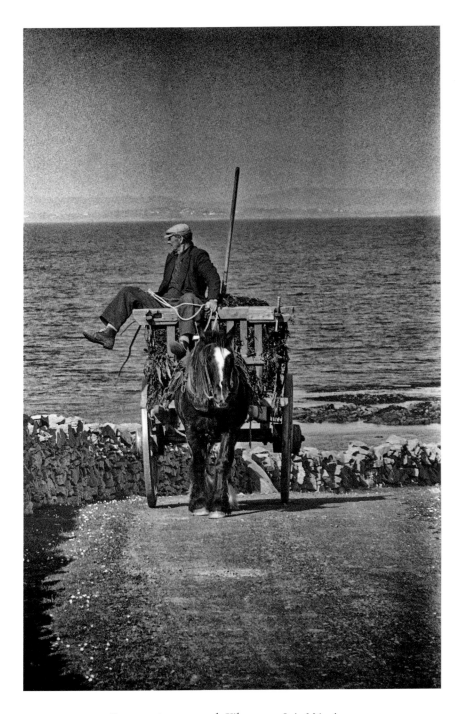

Transporting seaweed, Kilmurvey, Inis Mór, Aran

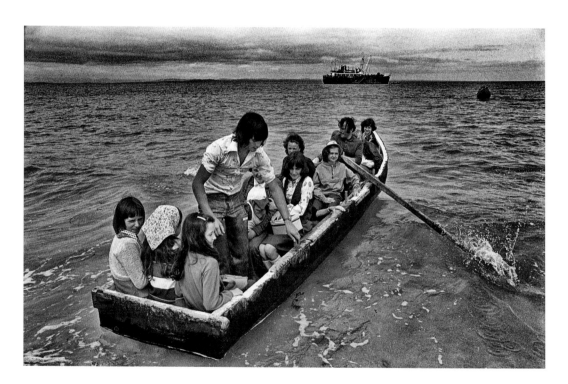

Departing Inis Oírr, Aran, for the Naomh Éanna *sailing to Galway*

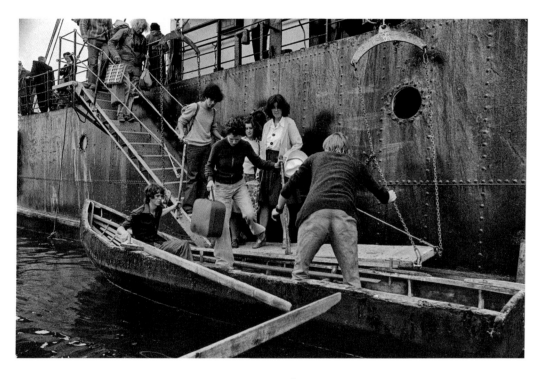

Disembarking from the Naomh Éanna *for Inis Oírr, Aran*

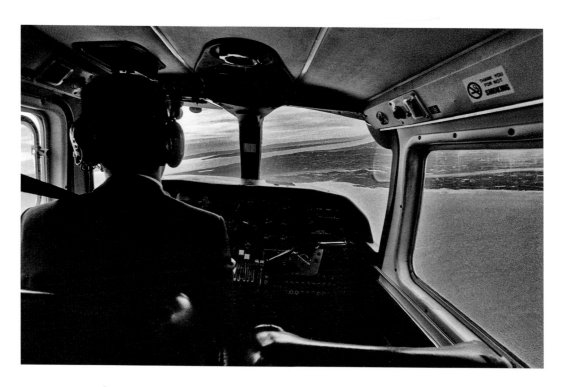

Aer Arann flying into Inis Meáin, Aran

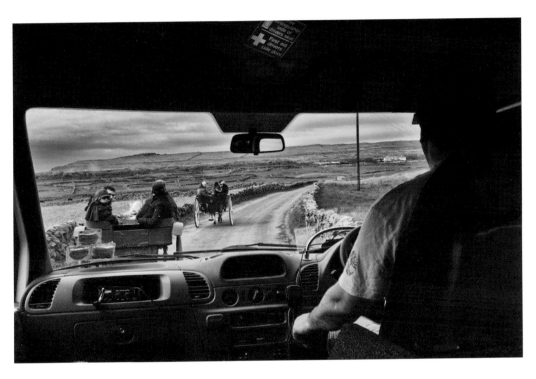

Pony traps and bus approaching Dún Aonghasa fort, Kilmurvey, Inis Mór, Aran

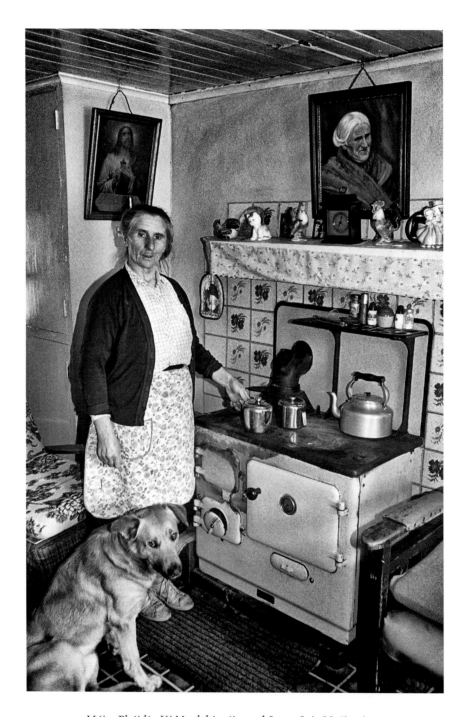

Máire Pháidín Uí Maolchiaráin and Juno, Inis Meáin, Aran

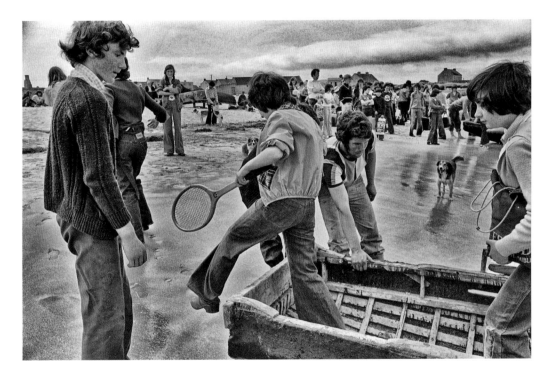

Gaelgóirí arrive for their three-week Irish language course on Inis Oírr, Aran

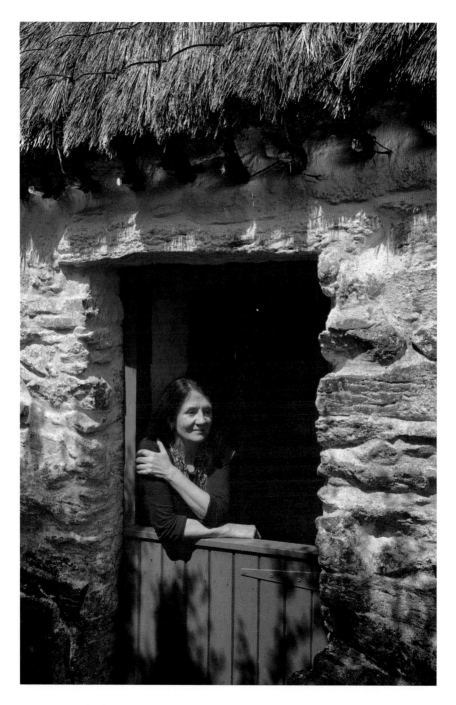

*Treasa Ní Fhátharta at her childhood home on Inis Meáin, Aran, which she has
dedicated as a museum to the playwright John Millington Synge*

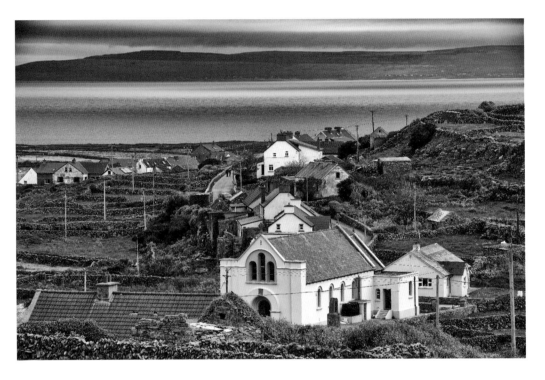

Baile an Teampaill, Inis Meáin, looking towards the coast of Clare

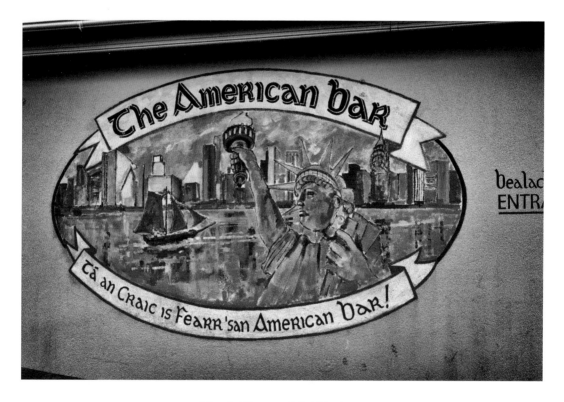

Mural, Kilronan, Inis Mór, Aran

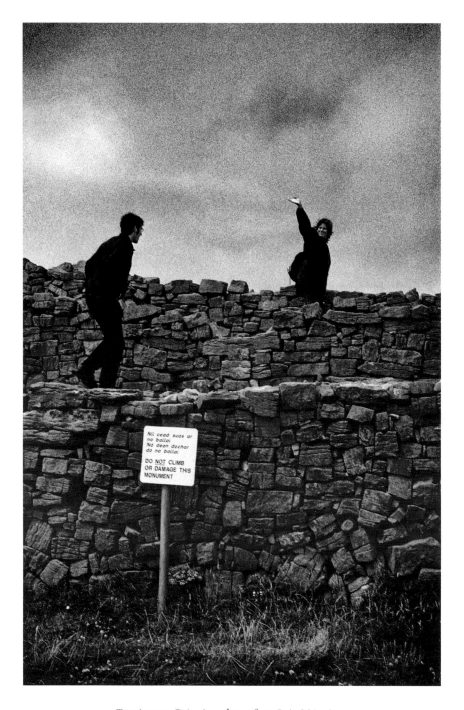

Tourists on Dún Aonghasa fort, Inis Mór, Aran

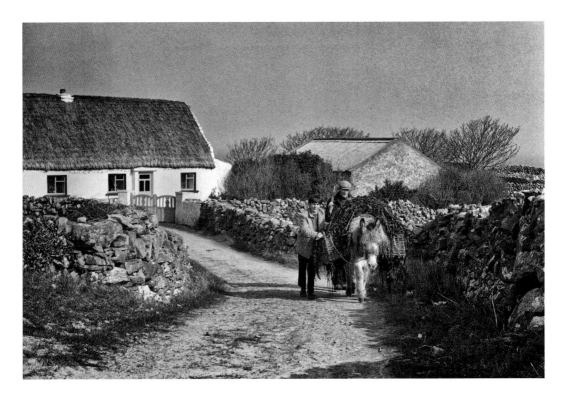

Eochaill, Inis Mór, Aran

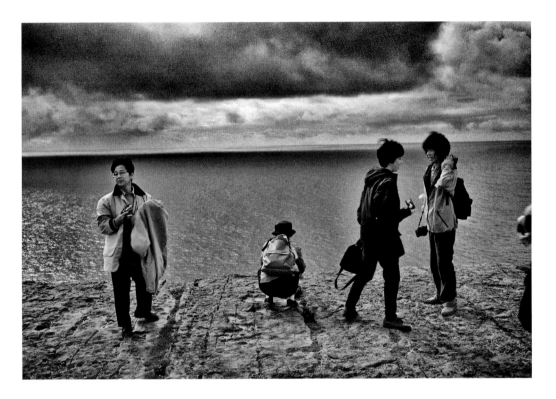

Tourists on Dún Aonghasa fort, Inis Mór, Aran

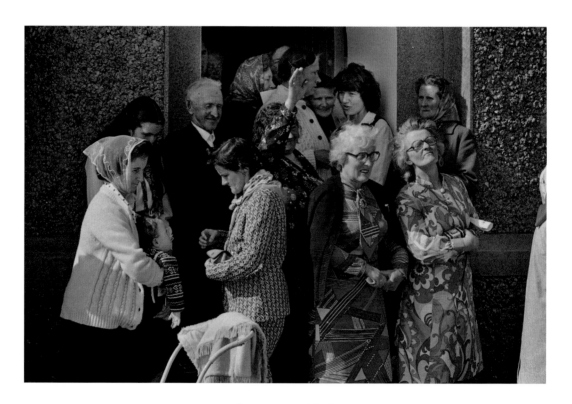

After Mass, Inishbofin

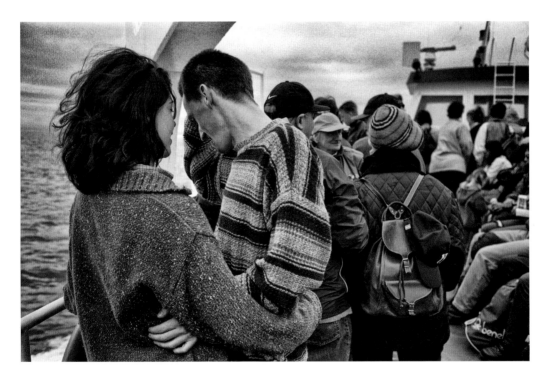

Ferry sailing from Inis Mór, Aran

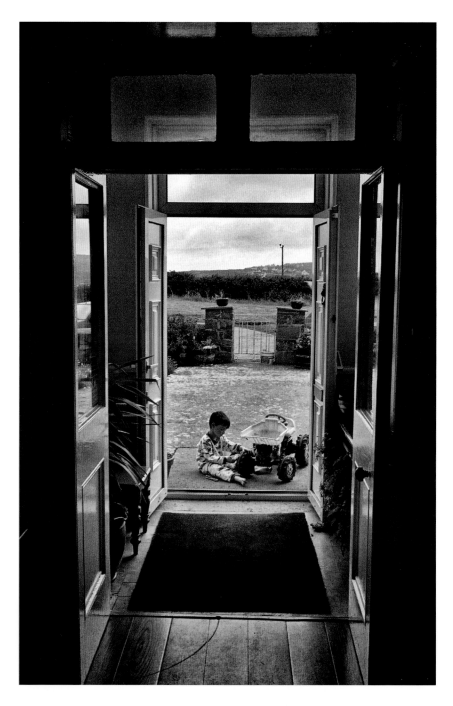

Noel Joyce, Kilmurvey House, Inis Mór, Aran

Wild flower and limestone, Inis Mór, Aran

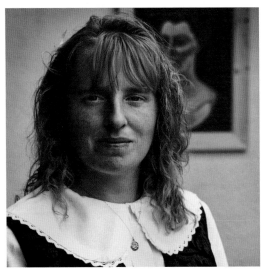

Frances Cunnane, Inishbofin

John Michael Coyne, Inishbofin

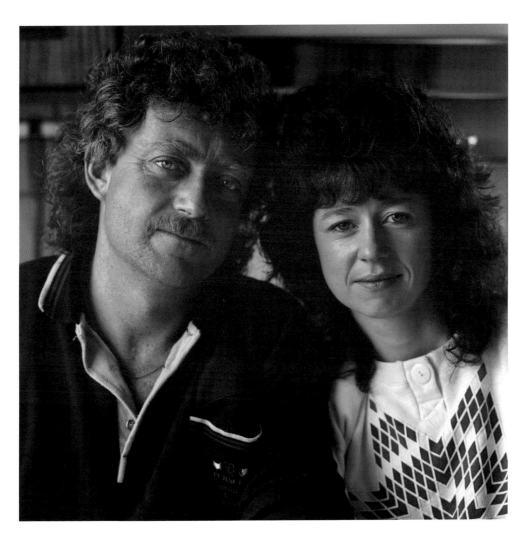

John and Mary Moran, Clare Island

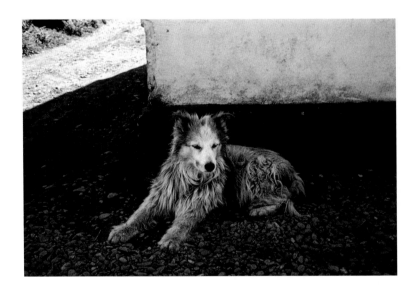

Wendy Maher's dog Lady, East End, Inishbofin

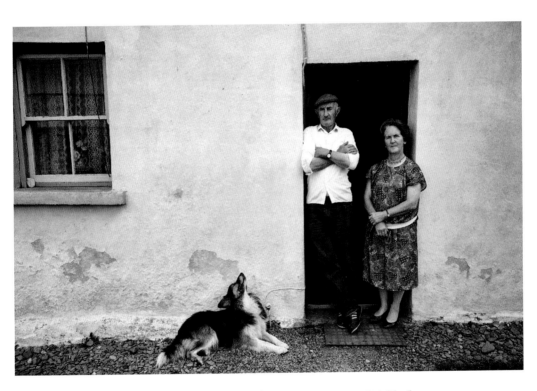

James and Patsy Coyne with Diver, Westquarter, Inishbofin

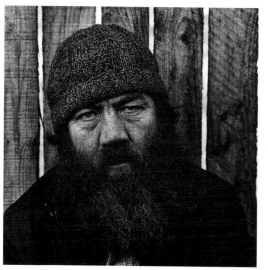

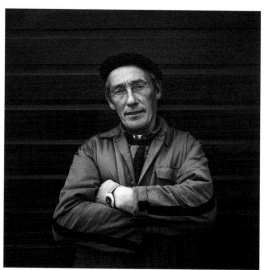

Laurence Ward, Inishbofin

John Lavelle, Inishbofin

Day's Bar at Christmas, Inishbofin

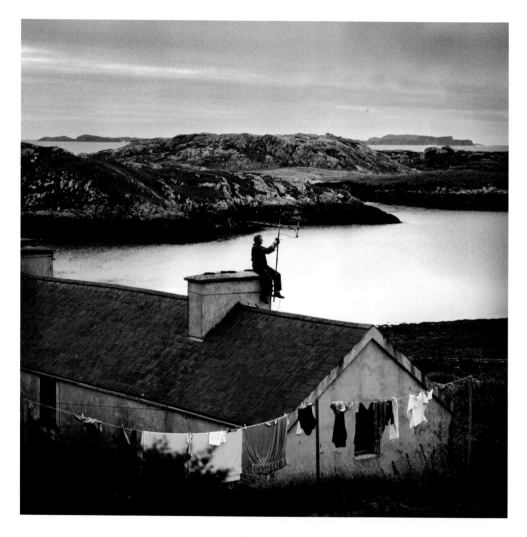

Máirtín Cloonan, Inishbofin

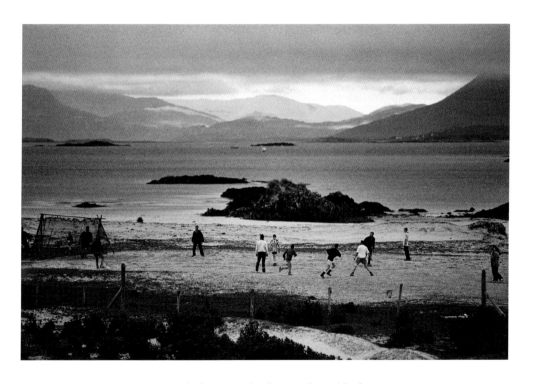

Football on Dumhach Strand, Inishbofin

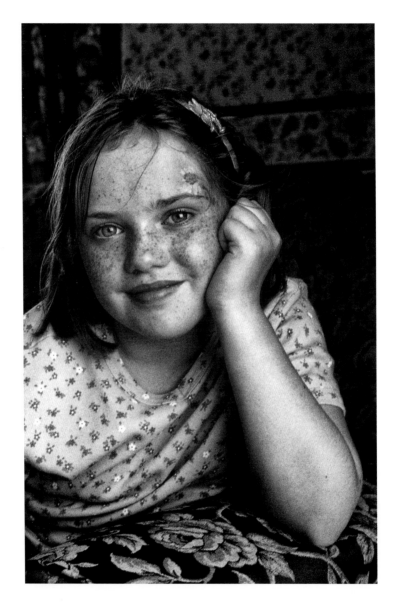

Aisling Flaherty, Gort na gCapall, Inis Mór, Aran

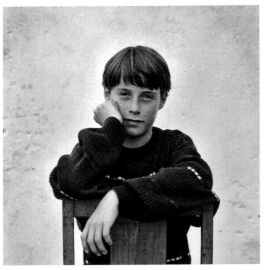

David Lavelle, Inishbofin

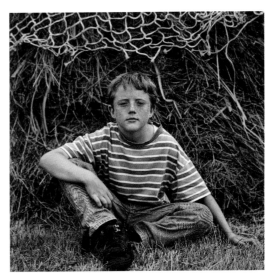

Peadar King, Inishbofin

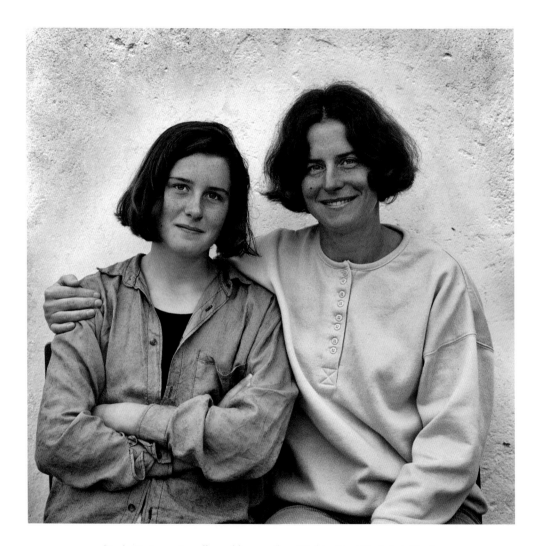

(L–r): Vivienne Lavelle and her mother, Nickie, East End, Inishbofin

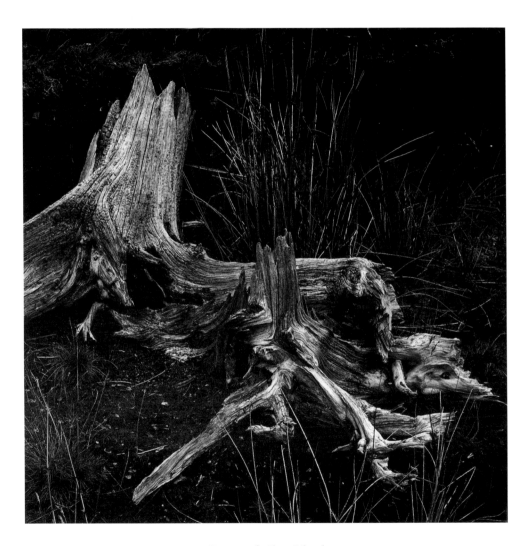

Bog wood, Clare Island

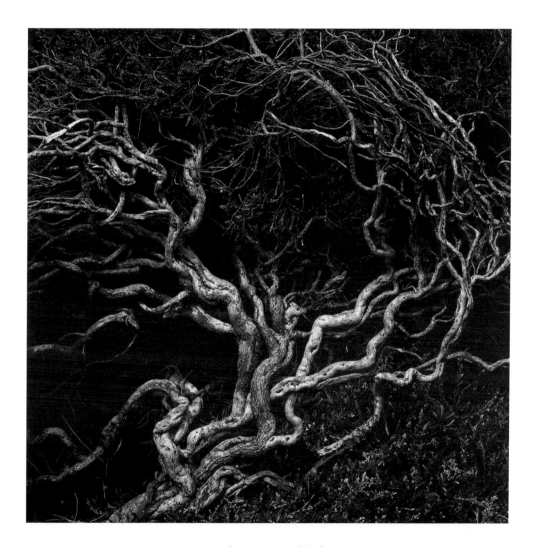

Heather roots, Inishbofin

Noel Schofield, Fawnmore, Inishbofin

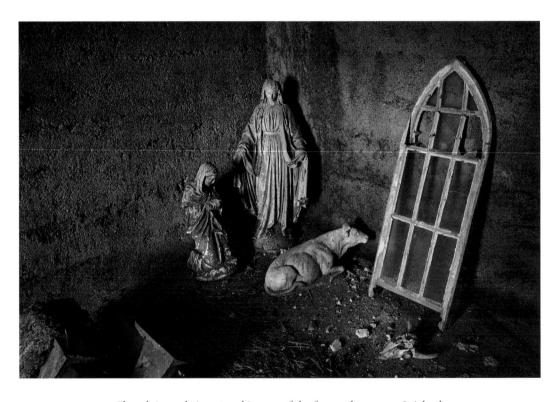

Church icons being stored in one of the former homes on Inishark

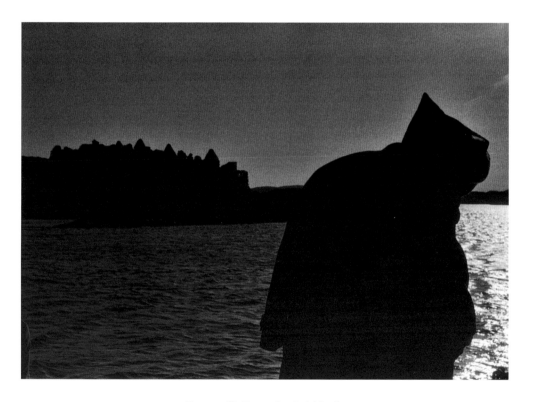

Cromwell's Barracks, Inishbofin

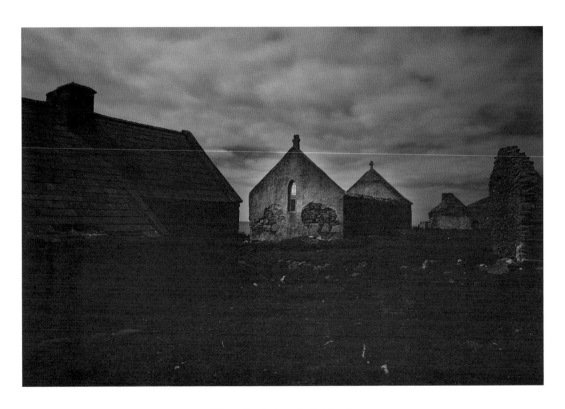

The ruined church, Inishark

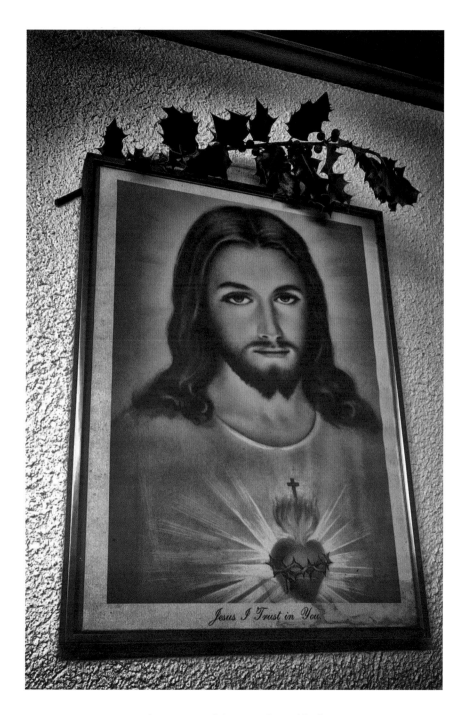

Christmas, Dolphin Hotel, Inishbofin

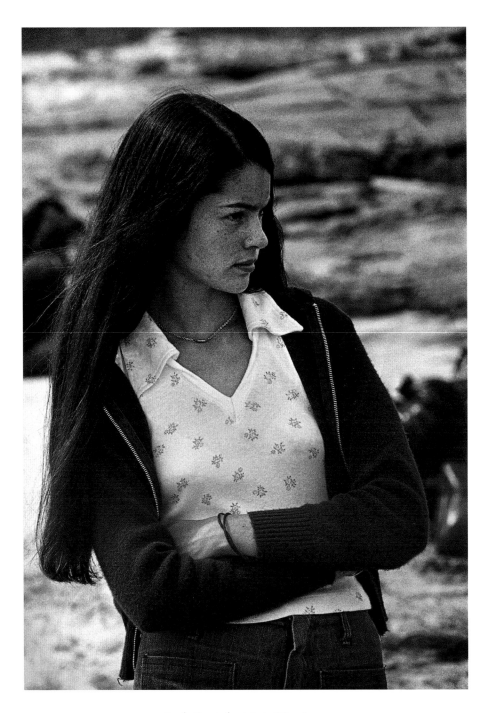

Gaelgóir student, Inis Oírr, Aran

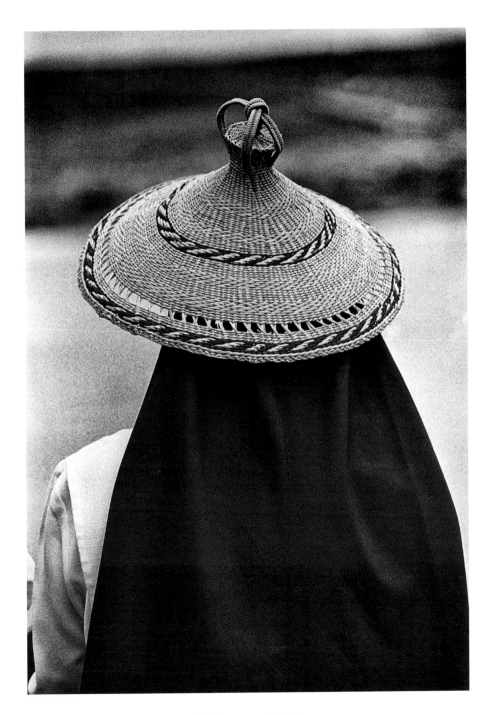

Visiting nun, Inis Oírr

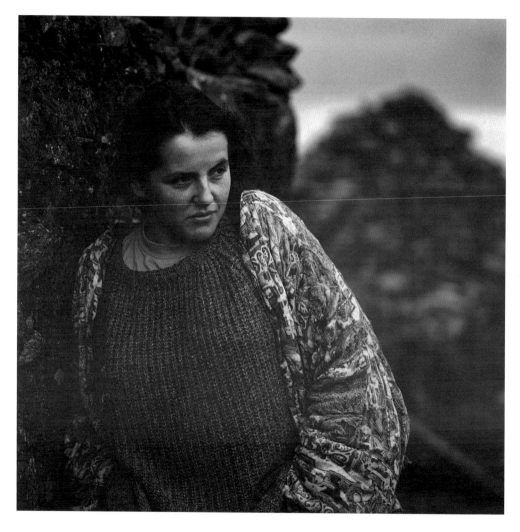

Anne Burke, Fawnmore, Inishbofin

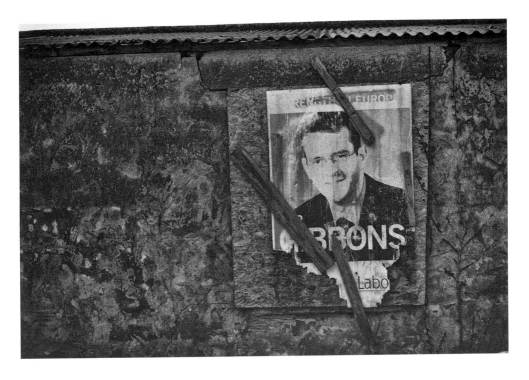

Election poster, Inis Mór, Aran

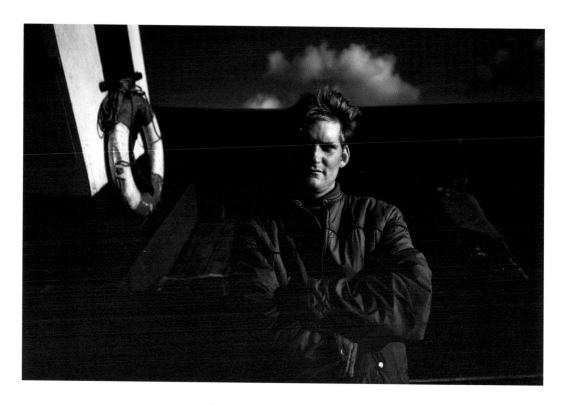

Aidan Day, Fawnmore, Inishbofin

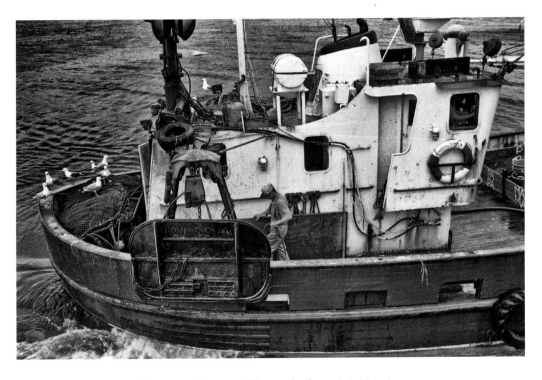

The Roving Swan *at Kilronan harbour, Inis Mór, Aran*

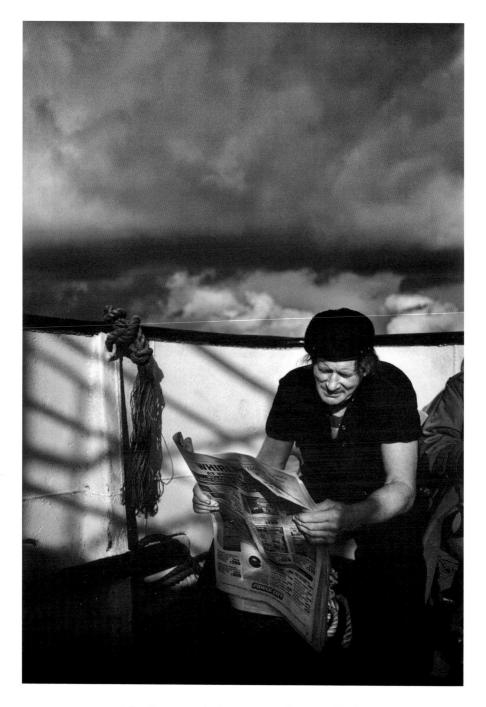

John Greene on the Dún Aengus *ferry, Inishbofin*

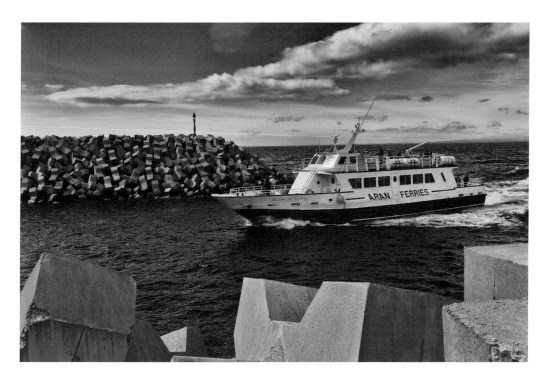

Banríon na Farraige ('Queen of the Sea') *ferry entering Inis Meáin harbour, Aran*

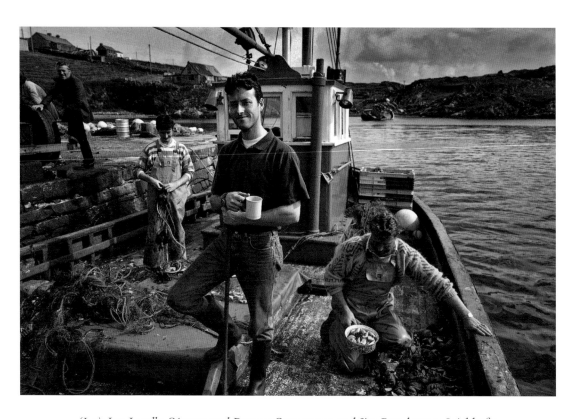

(L-r): Leo Lavelle, Séamus and Dermot Concannon and Jim Prendergast, Inishbofin

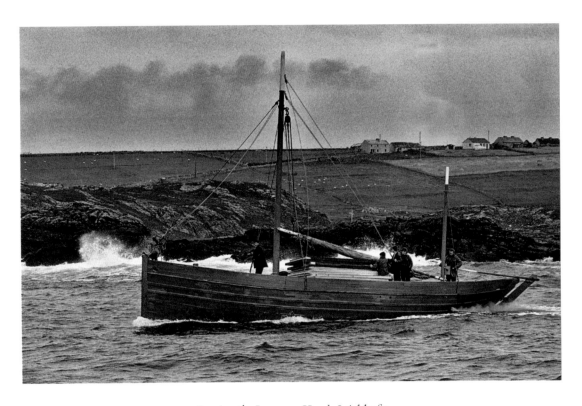

Passing the Leenane Head, *Inishbofin*

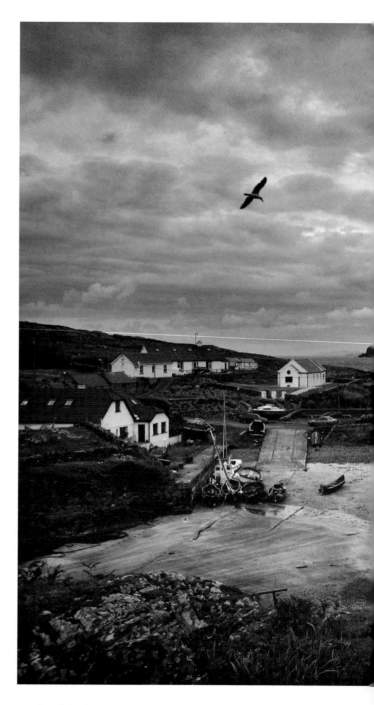

Inishturk harbour

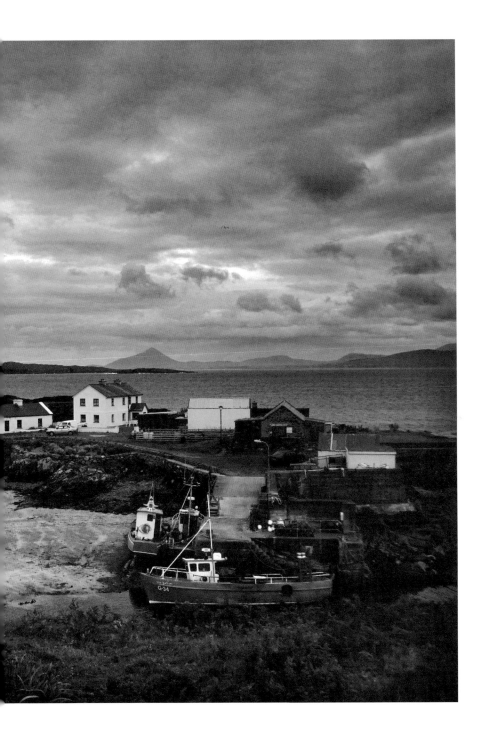

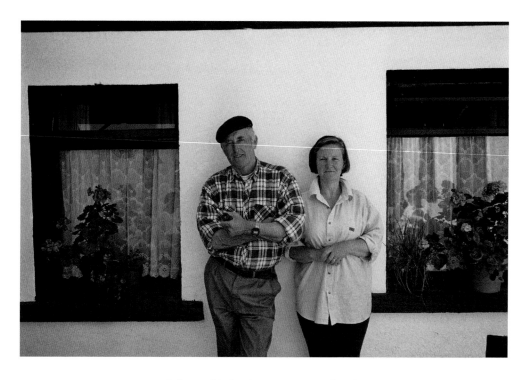

John and Delia Concannon, Inishturk

Blessing, Inishbofin

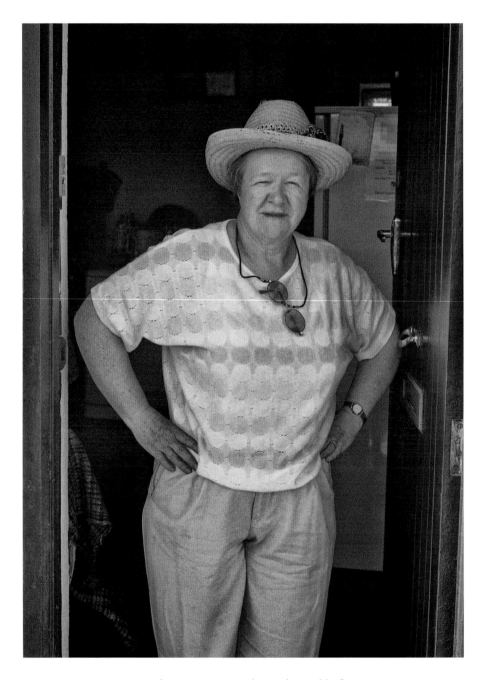

Bridget McCann, North Beach, Inishbofin

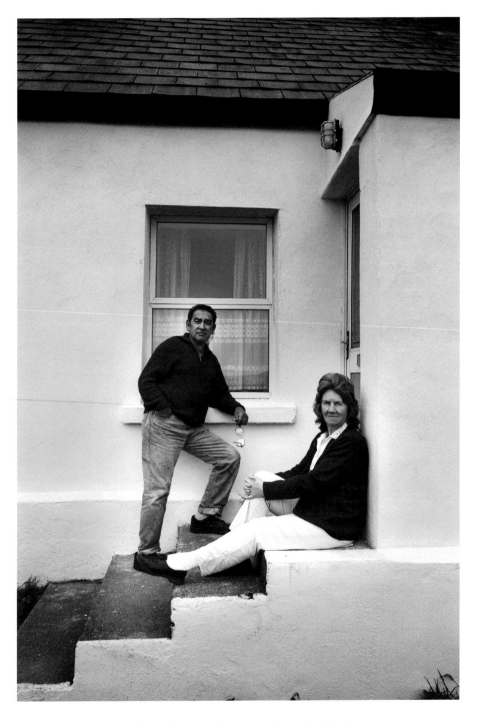

John and Marie Abeyta, East End, Inishbofin

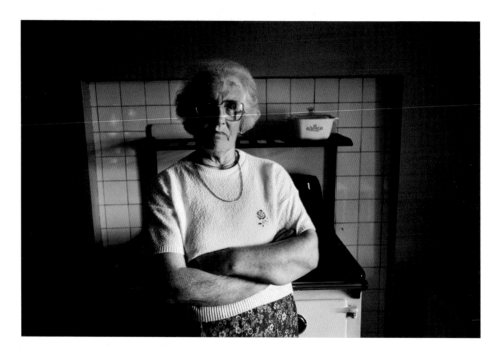

Kitty King, High Road, Inishbofin

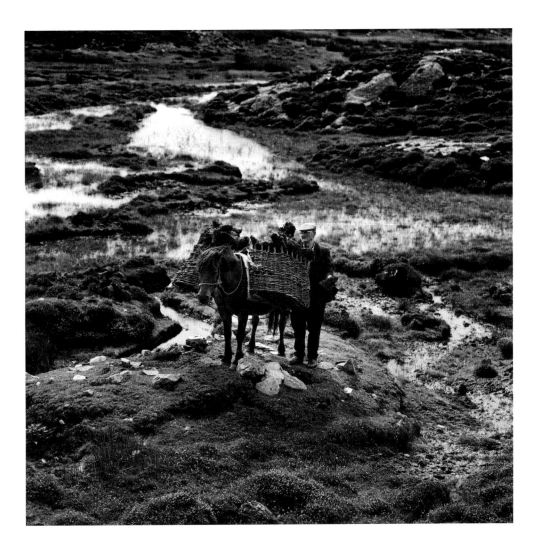

John Cunnane and Sam loading turf on Inishbofin

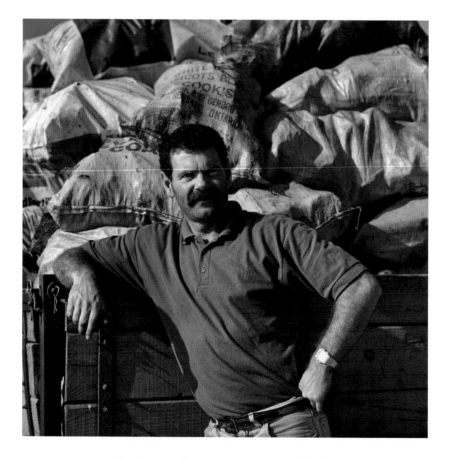

Declan O'Halloran, Westquarter, Inishbofin

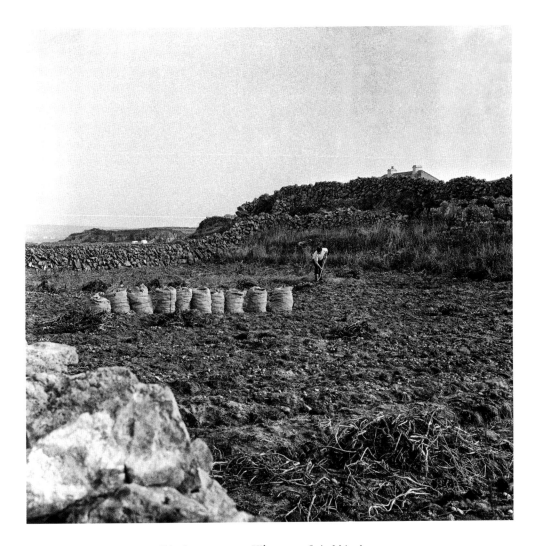

Digging potatoes, Kilmurvey, Inis Mór, Aran

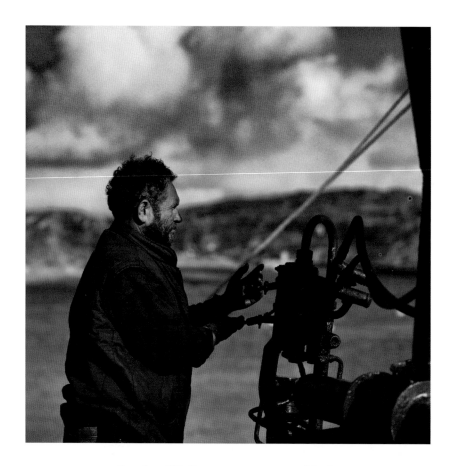

Brendan O'Halloran, Fawnmore, Inishbofin

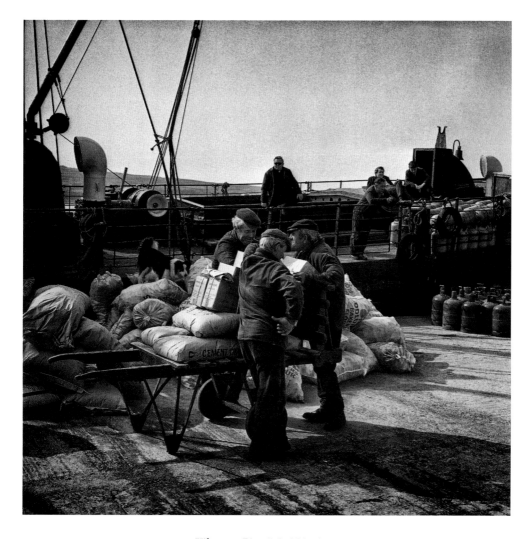

Kilronan Pier, Inis Mór, Aran

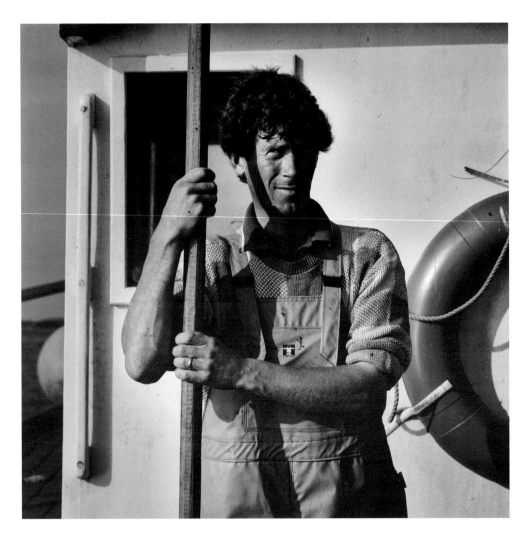

Francis O'Halloran, Westquarter, Inishbofin

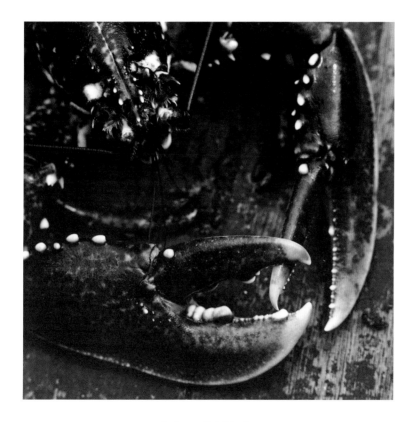

Lobster, Inishbofin

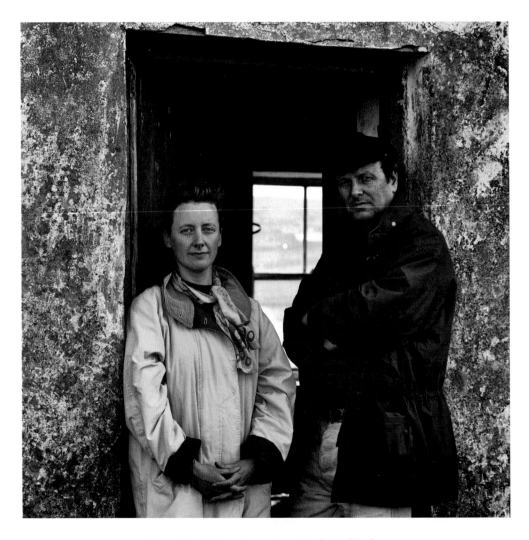

Carmel and Liam Byrne, East End, Inishbofin

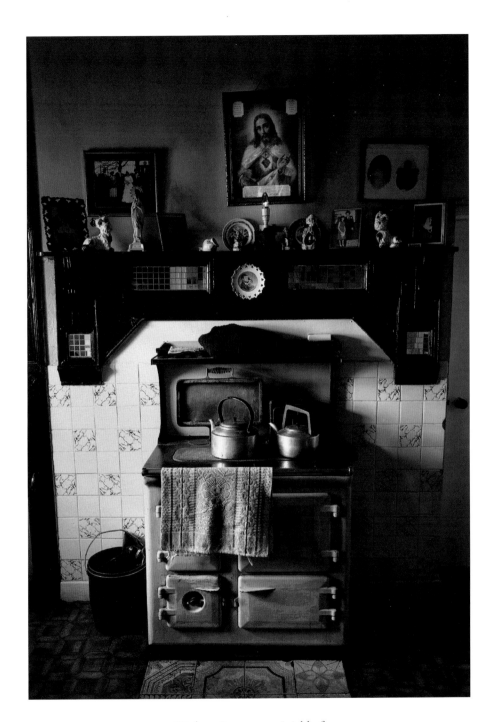

Kitchen, Fawnmore, Inishbofin

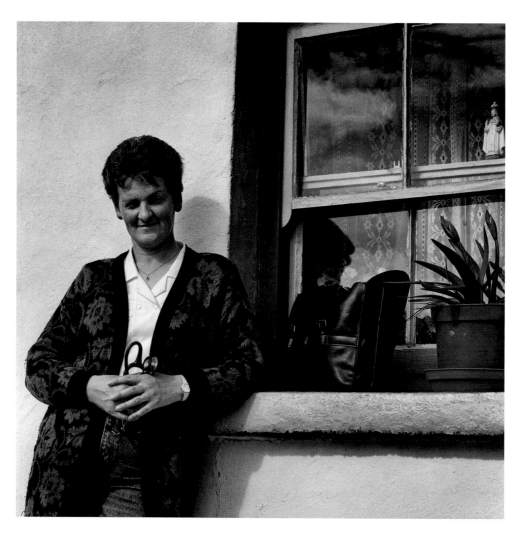

Mary Guckian Day, former nurse, Inishbofin

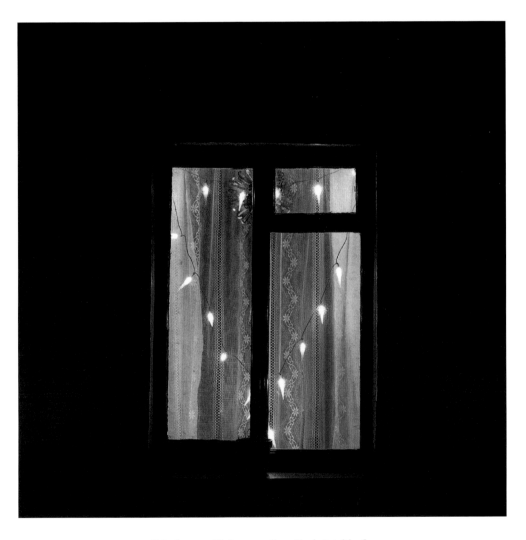

Window at Christmas, East End, Inishbofin

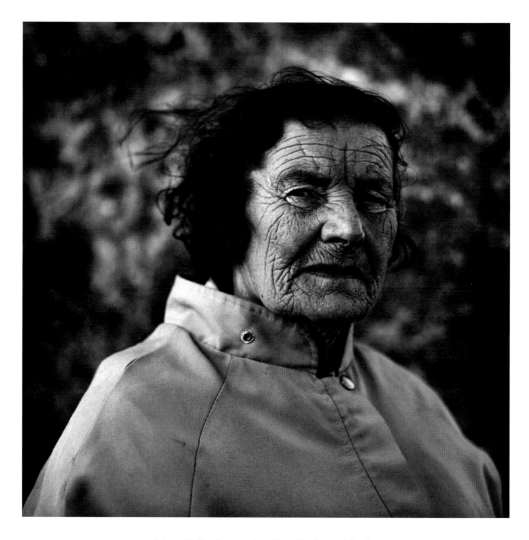

Mary Gallagher Burke, East End, Inishbofin

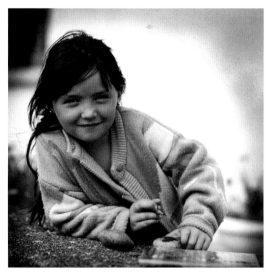

Avril Day, Inishbofin

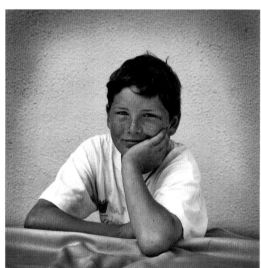

Ian Day, Inishbofin

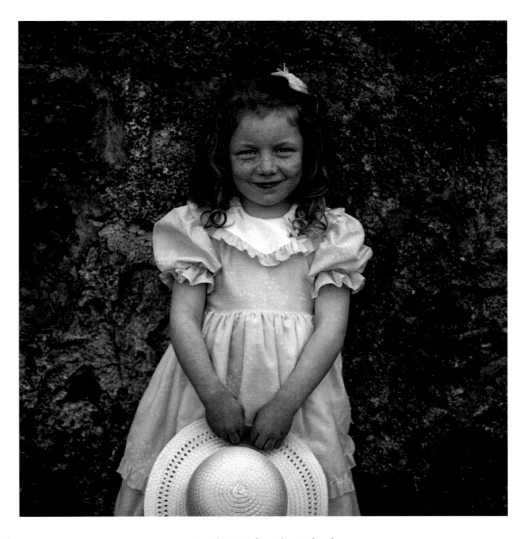

Sarah McCabe, Clare Island

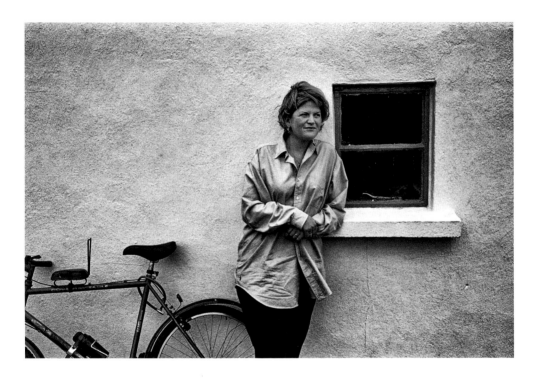

Michelle Conneely, Sruthán, Inis Mór, Aran

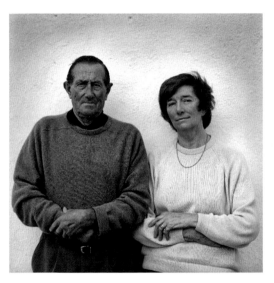

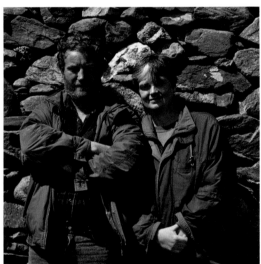

Paddy and Margaret Murray, Inishbofin

Jim and Ann Prendergast, Inishbofin

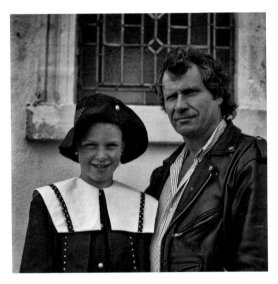

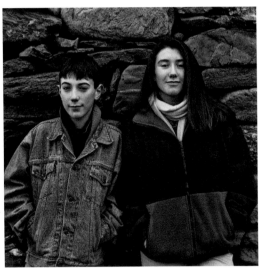

Aisling O'Malley and her father,
Michael Bob, Clare Island

Caimin Coyne and his sister,
Cliodhna, Inishbofin

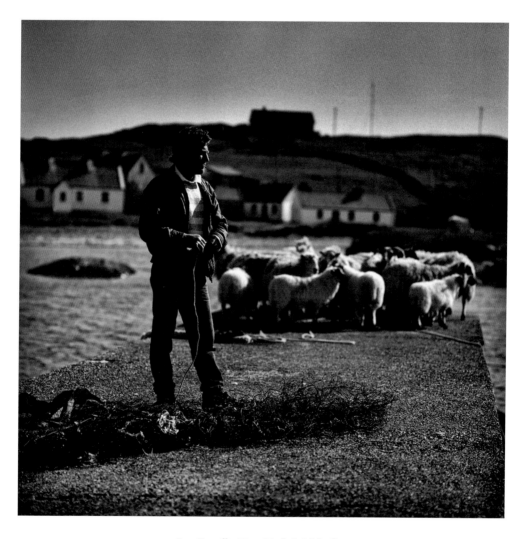

Leo Lavelle, East End, Inishbofin

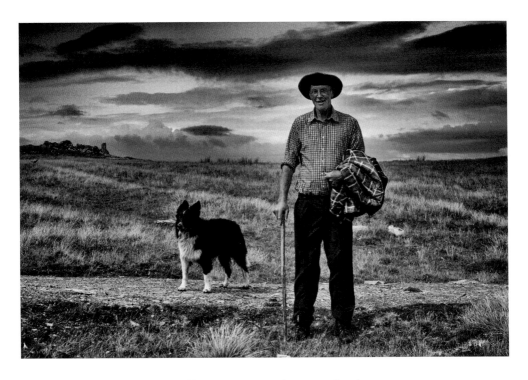

Paddy Joe Heanue and Pup, Inishturk

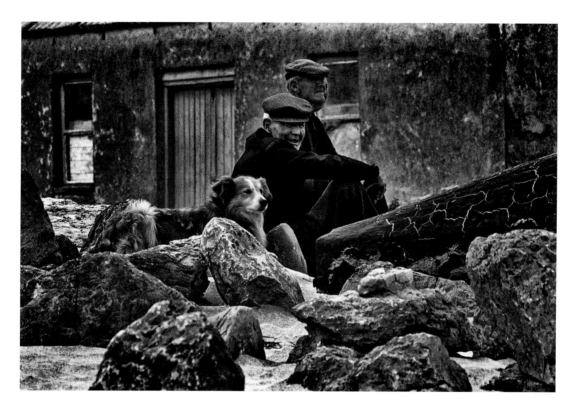

Awaiting the arrival of the ferry, Inis Oírr, Aran

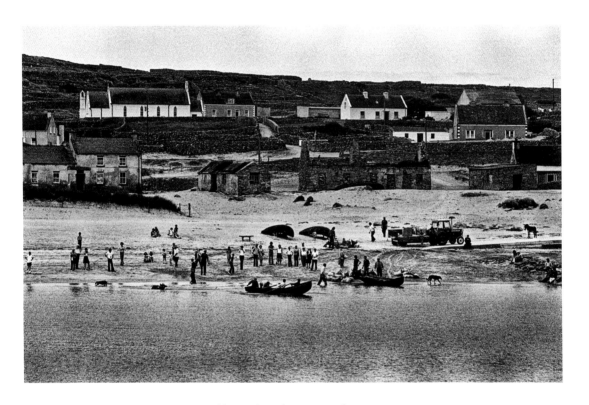

An Trá and beyond, Baile an tSéipéil, Inis Oírr, Aran

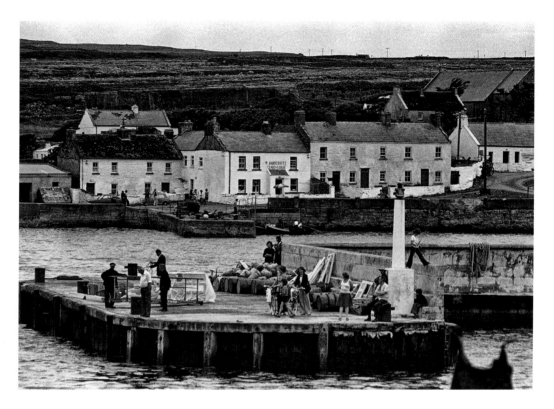

Kilronan, Inis Mór, Aran

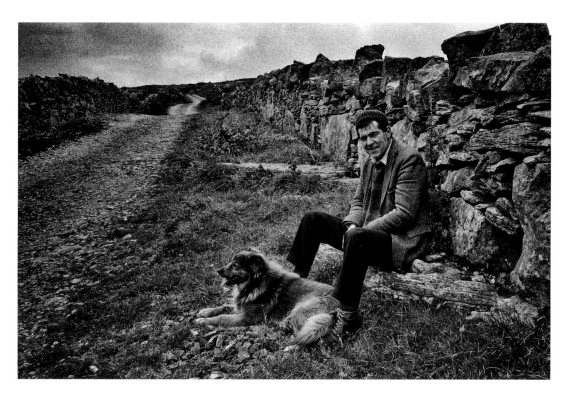

Padraig Kilmartin and Brownie, Inis Mór, Aran

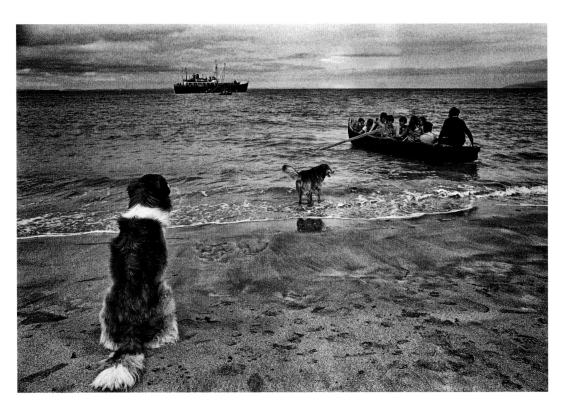

Gaelgóirí students depart for the Naomh Éanna *ferry to Galway, following their Irish language studies on Inis Oírr, Aran*

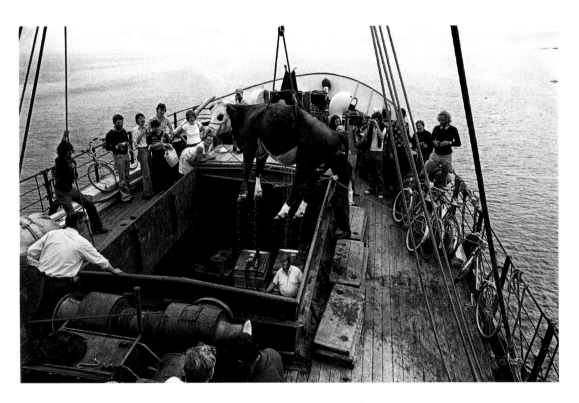

A cow being winched from the hold of the Naomh Éanna *ferry to be towed by currach into Inis Oírr, Aran*

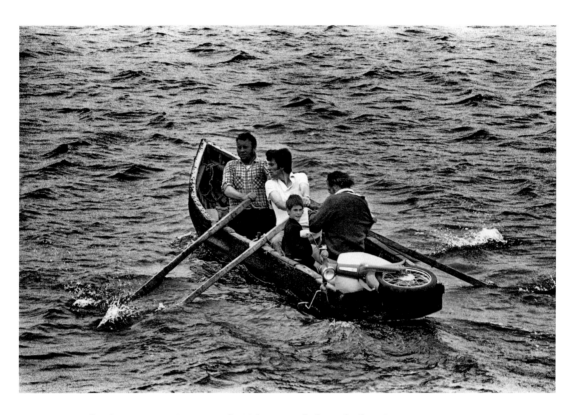

Islanders transporting a Honda 50 by currach from the ferry into Inis Meáin, Aran

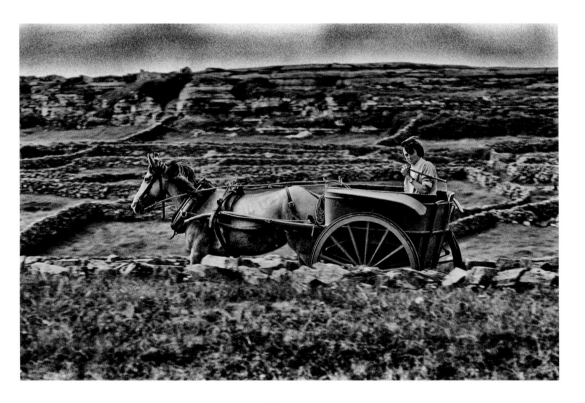

Pony and trap, Kilmurvey, Inis Mór, Aran

Kathleen O'Halloran Morrison and Cathy Coyne, Middlequarter, Inishbofin

Alice O'Halloran and her mother, Mary, North Beach, Inishbofin

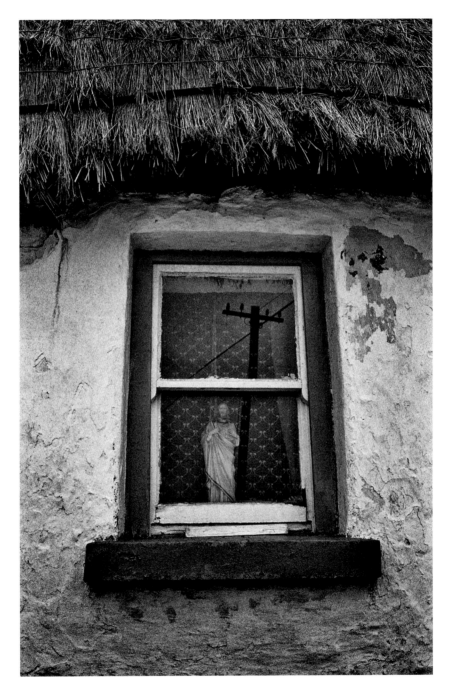

Cottage at Sruthán, Inis Mór, Aran

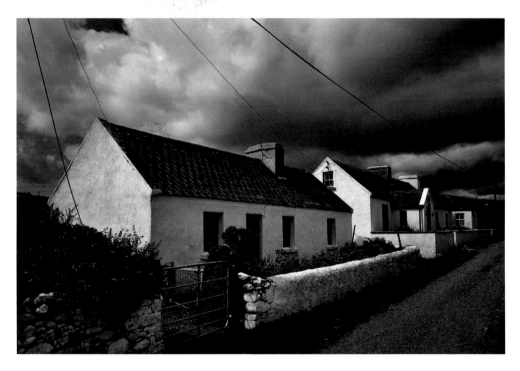

Cottages, East End, Inishbofin

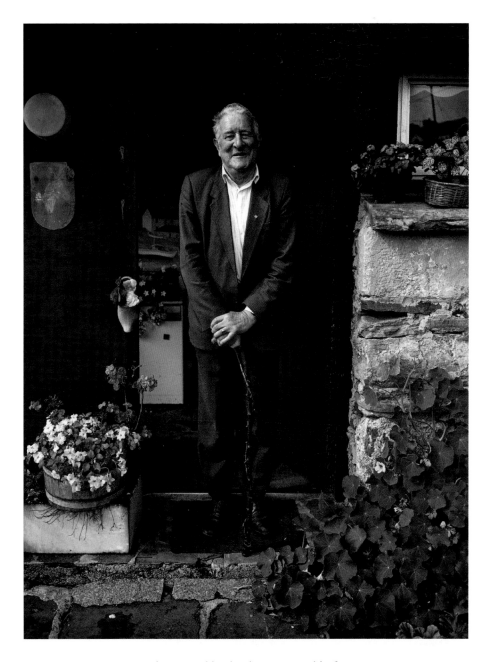

Miko Day, Old School House, Inishbofin

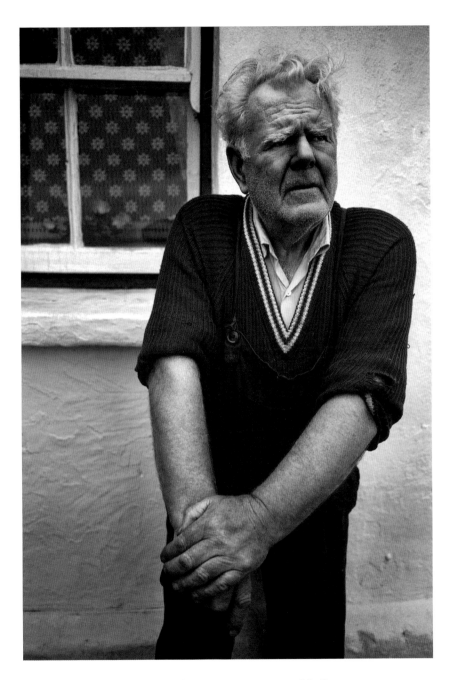

Frank O'Halloran, Westquarter, Inishbofin

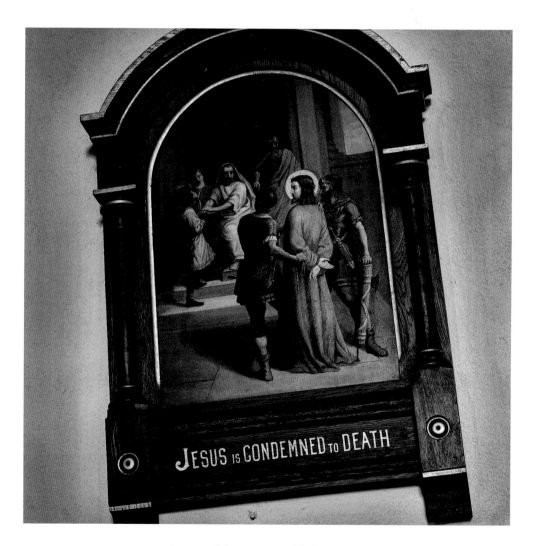

Station of the Cross, Inishbofin church

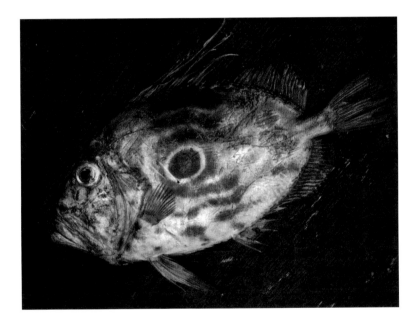

John Dory, Inishturk

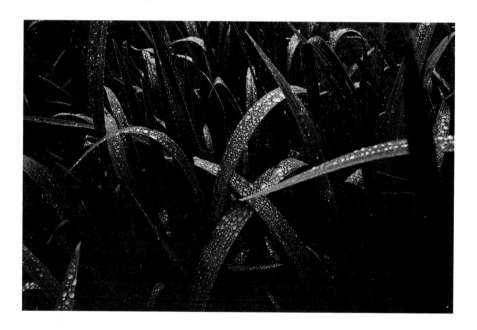

Wild iris leaves, Inishturk

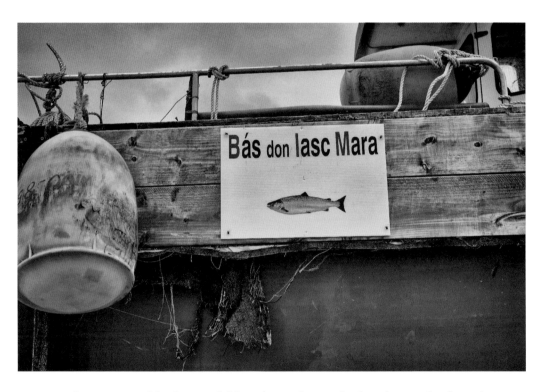

Bás don Iasc Mara ('death to sea fish'), a play on the initials of Bórd Iascaigh Mhara, the Irish Sea Fisheries Board, which has come up against strong opposition from the people of Inis Oírr, Aran, to the Board's plans for a major fish farm, the largest of its kind in Europe, due for development near the island

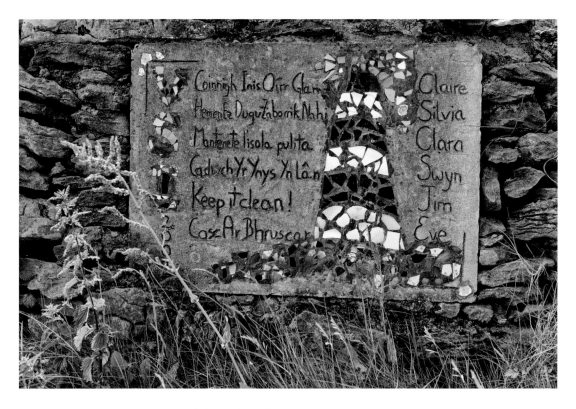

Multilingual anti-litter sign, Inis Oírr, Aran

Blackberry briars, Inishturk

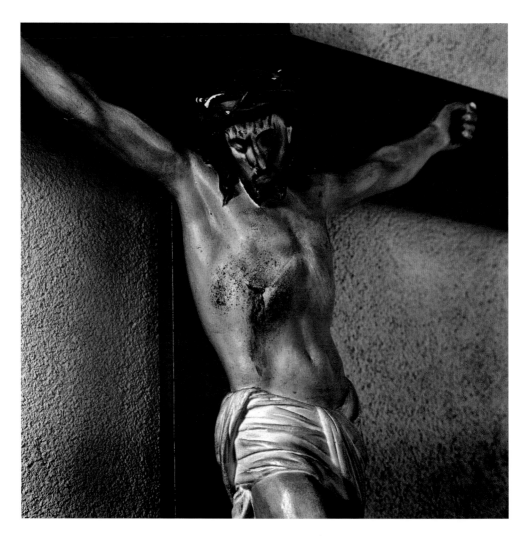

Crucifix, Inishbofin church

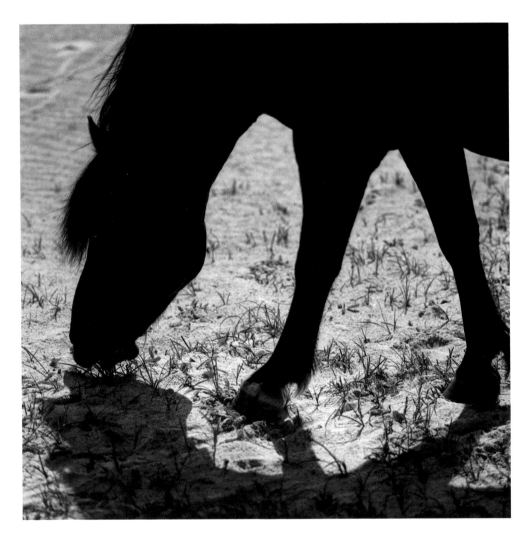

Sailor on Dumhach Strand, Inishbofin

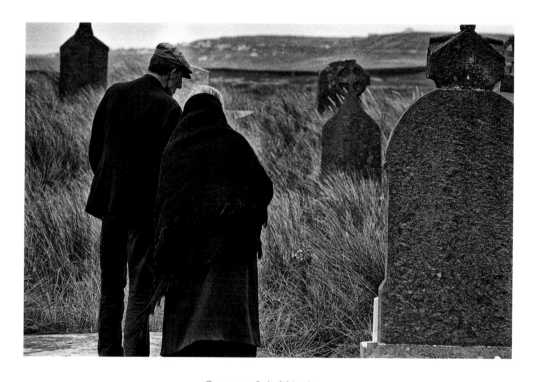

Cemetery, Inis Mór, Aran

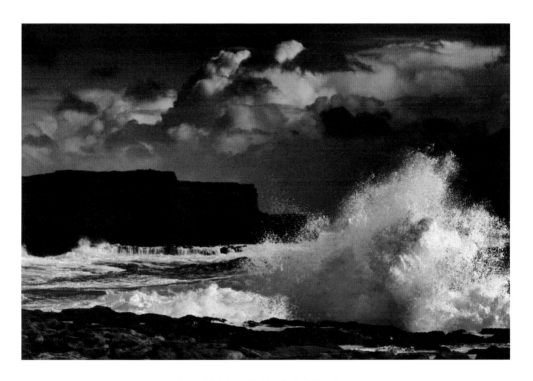

Port Bhéal an Dúin, Inis Mór, Aran

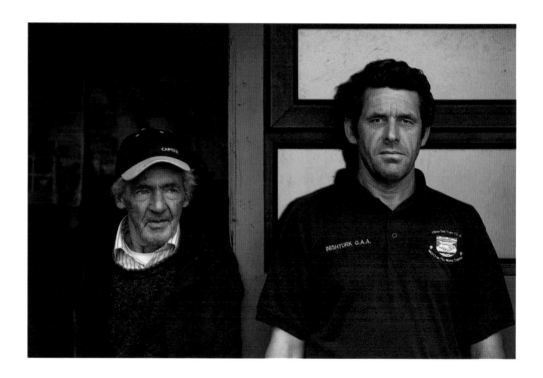

(L–r): Patrick Joseph O'Toole and Pat Heaney, Inishturk

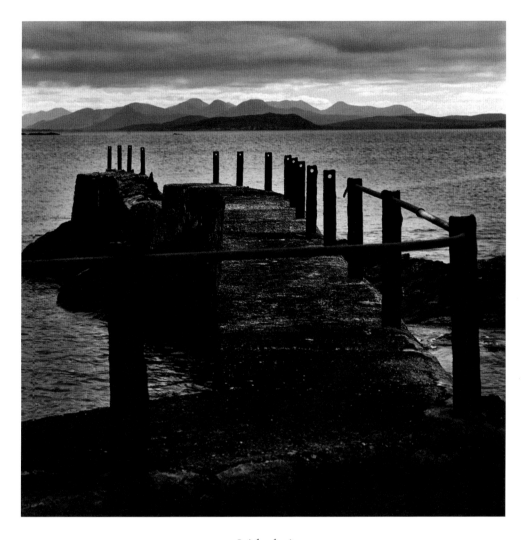

Inishark pier

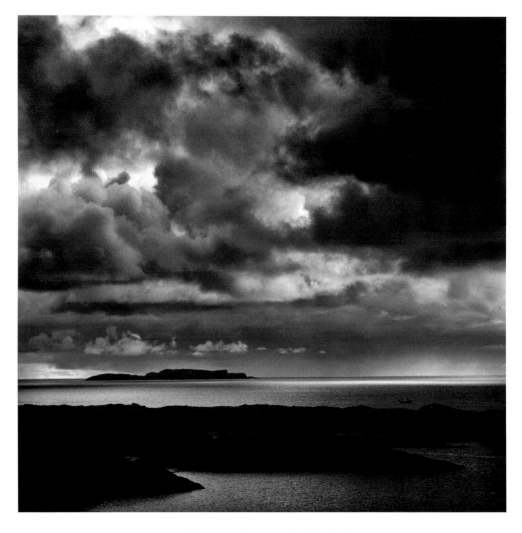

Inishbofin harbour and High Island

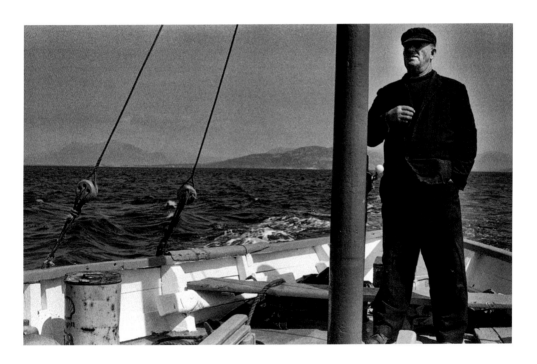

Paddy O'Halloran sailing the Leenane Head, *Inishbofin*

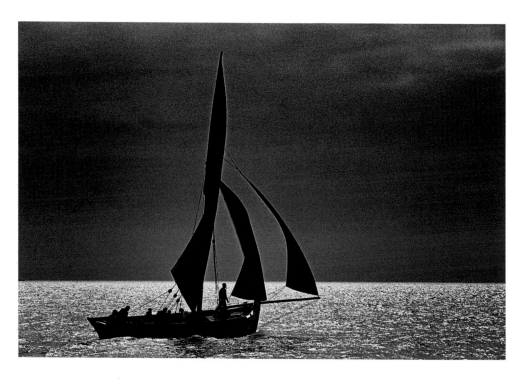

The American Mór *hooker, once used for the turf trade from*
Connemara to the Aran Islands

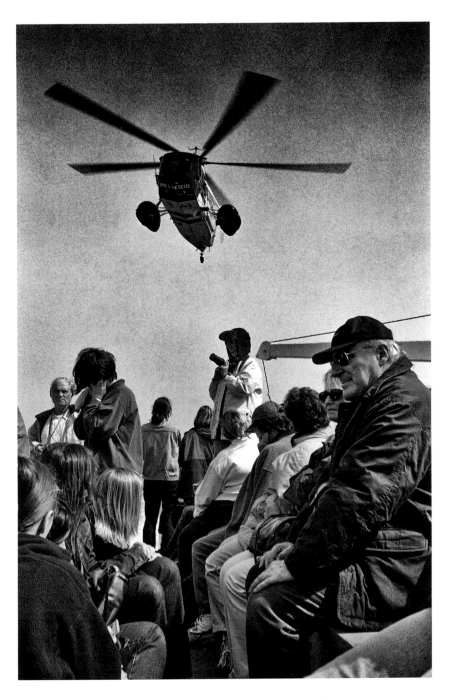

Marine rescue helicopter on a training exercise with Aran Island Ferries to Inis Mór, Aran

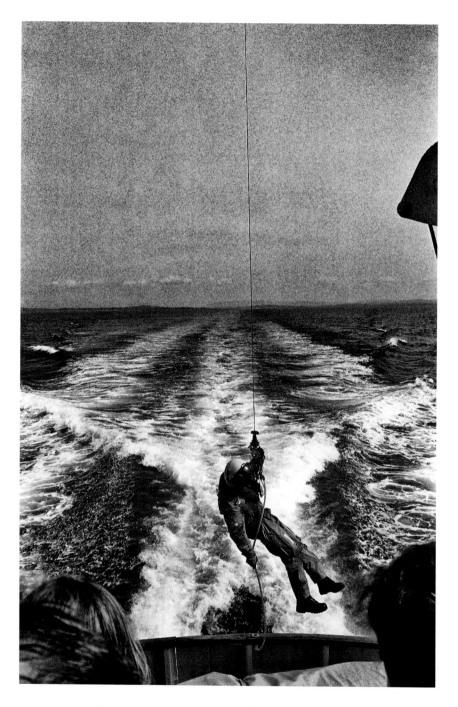

Marine rescue training on the ferry to Inis Mór, Aran

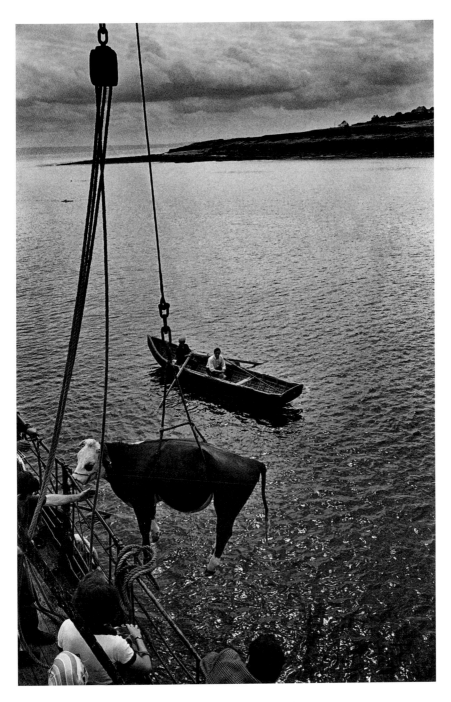

A cow being lowered by winch from the Naomh Éanna *ferry to be towed by currach into Inis Oírr, Aran*

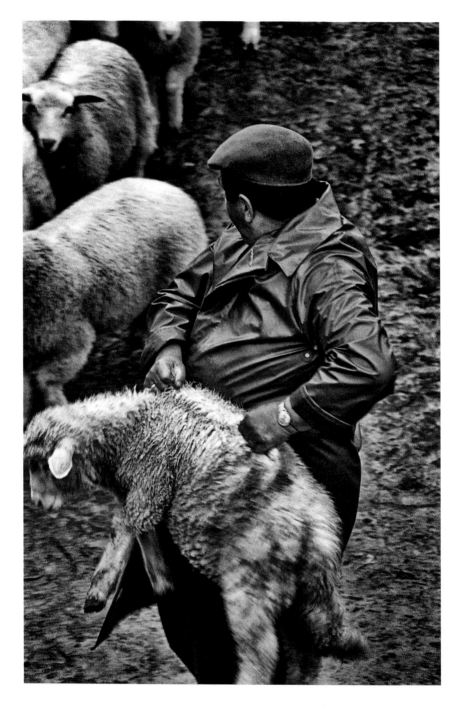

Paddy Cantwell, former captain of the Naomh Éanna *ferry
on Kilronan pier, Inis Mór, Aran*

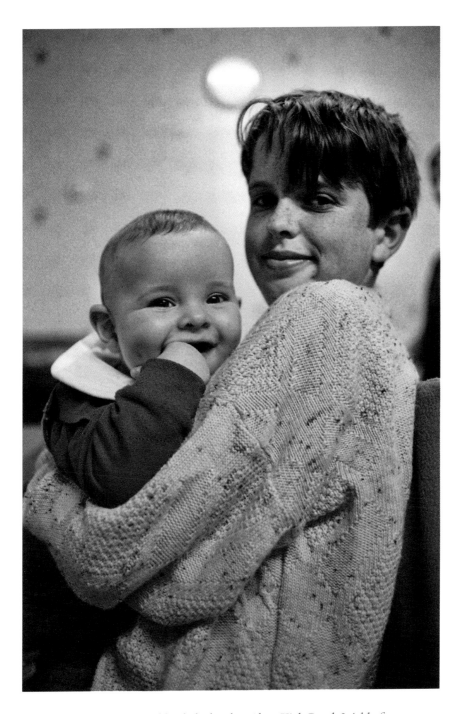

Eamonn Day and his baby brother, Alan, High Road, Inishbofin

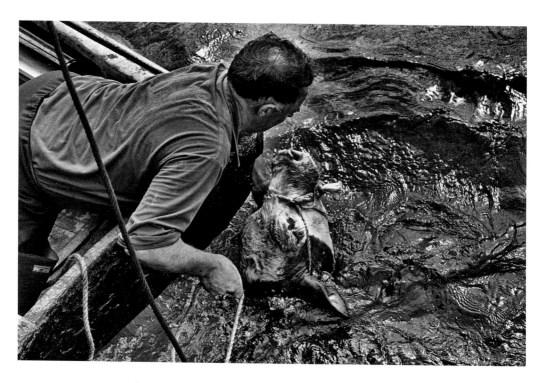

Rúairí Ó Conghaile transporting a cow from the ferry to Inis Oírr, Aran

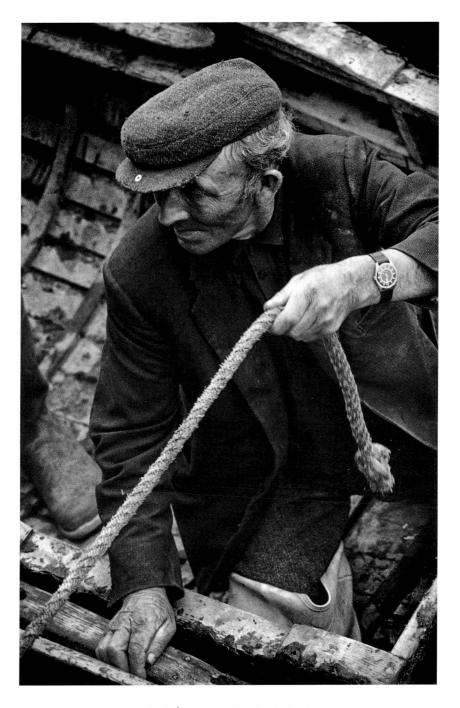

Micheál Ó Domhnaill, Inis Meáin, Aran

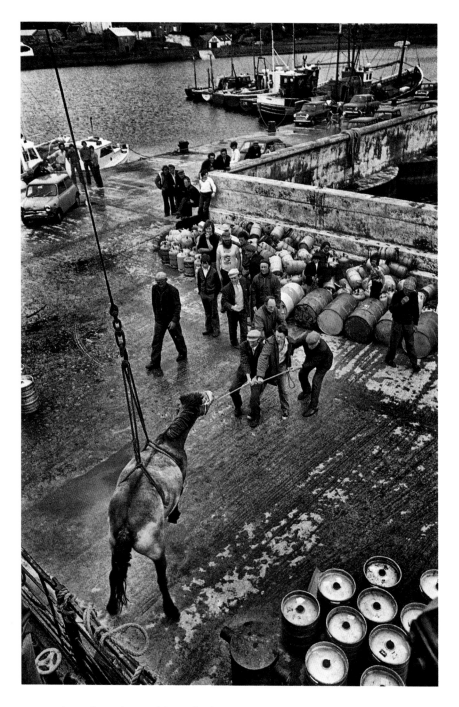

A horse being lowered from the ferry on to Kilronan pier, Inis Mór, Aran

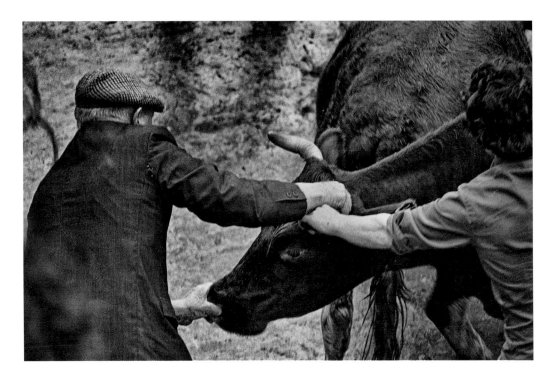

A cow being manoeuvred to the ferry at Kilronan for transport to Galway

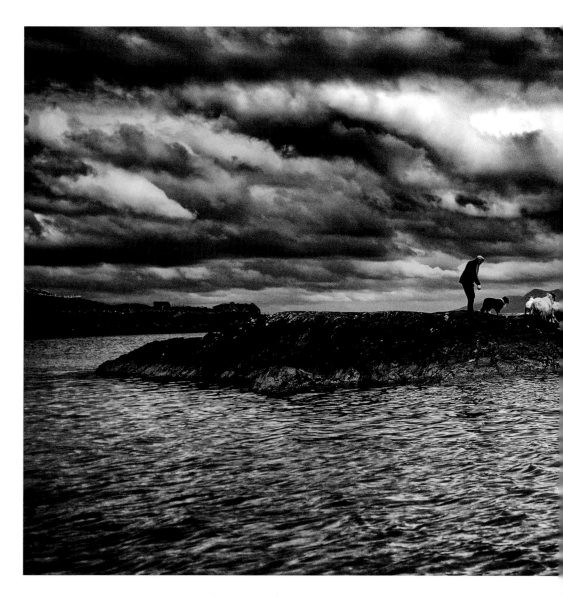

Transporting sheep to Damhoileán, Inishbofin

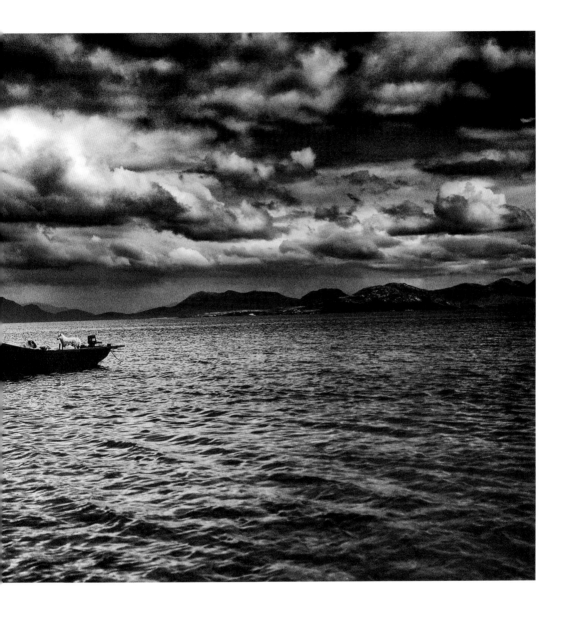

Margaret O'Halloran, Westquarter, Inishbofin

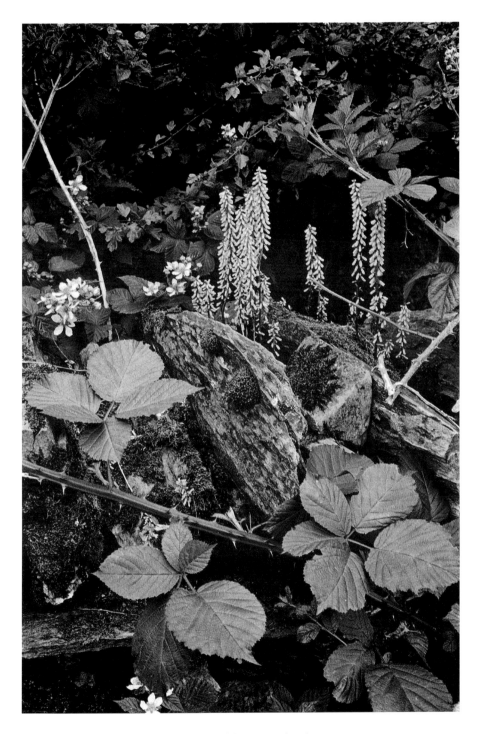

Flora and foliage, Inishturk

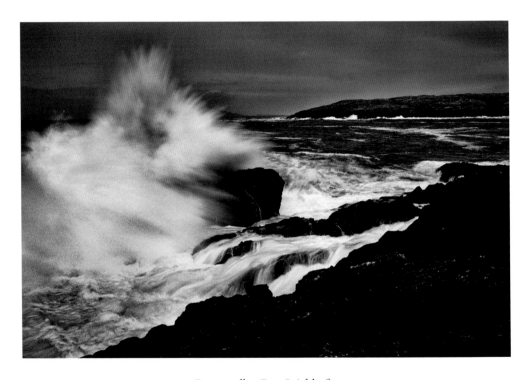

Bunamullen Bay, Inishbofin

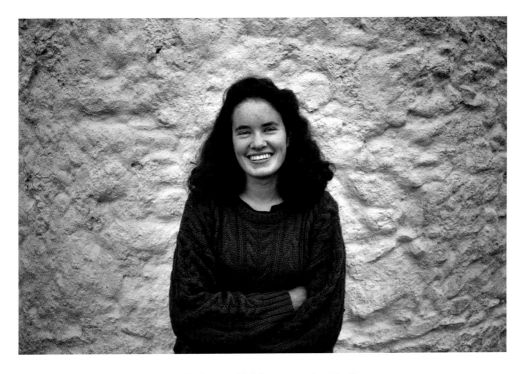

Marie Coyne, Middlequarter, Inishbofin

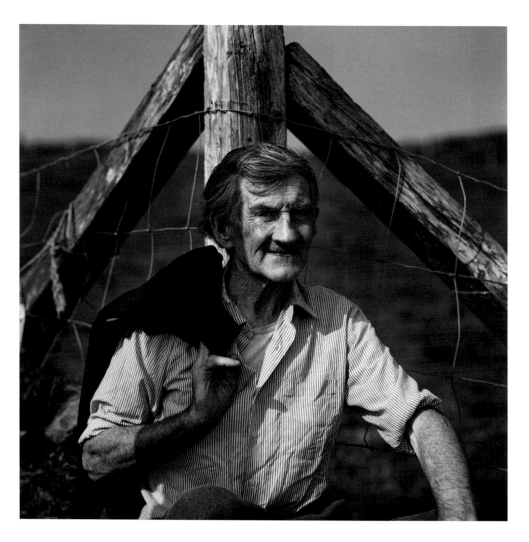

Máirtín D'Arcy, East End, Inishbofin

Honeysuckle amid the blackberry briars, Inis Mór, Aran

Aoife O'Toole, Baile Thiar, Inishturk

Burnet Rose, Inis Mór, Aran

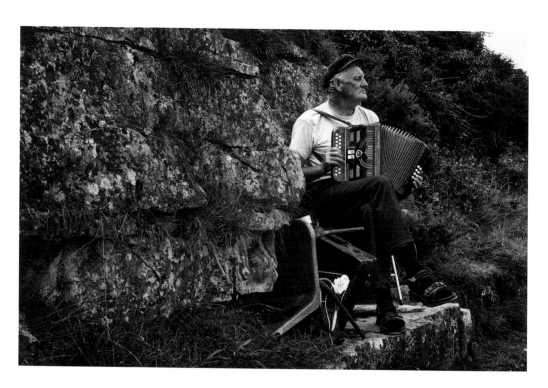

Paddy Quinn entertaining tourists on the way to Dún Aonghasa fort, Inis Mór, Aran

The American Bar, Kilronan, Inis Mór, Aran

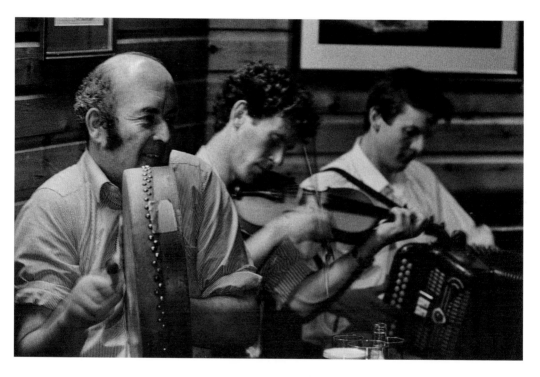

Inishbofin musicians: Michael Joe O'Halloran, bodhrán, Francis O'Halloran, fiddle and Paddy Joe King on the button accordion, known in traditional Irish music circles as 'the box'

Quentin O'Halloran, Fawnmore, Inishbofin

Philip Coyne, East End, Inishbofin

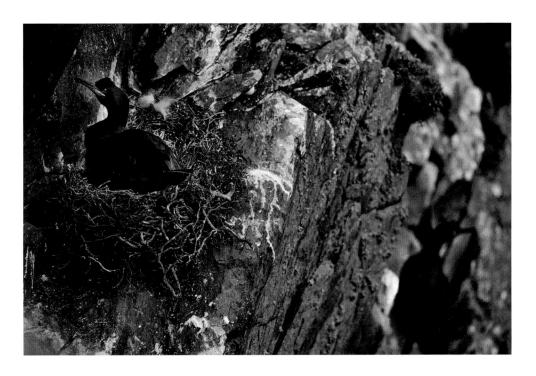

Shags nesting on the cliff face at Uaimh na gCáilleach, Inishbofin

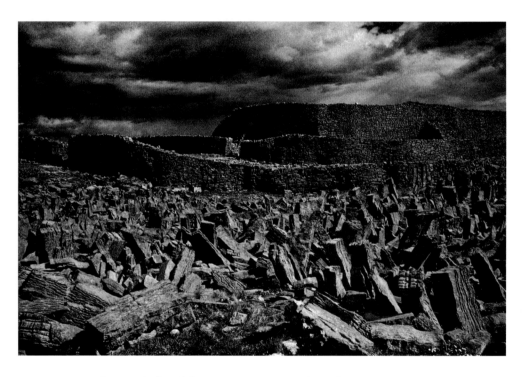

Chevaux-de-frise defence stones, Dún Aonghasa fort, Inis Mór, Aran

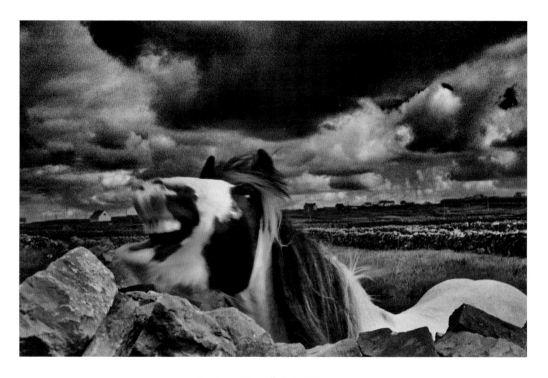

Gort na gCapall, Inis Mór, Aran

Kilmurvey, Inis Mór, Aran

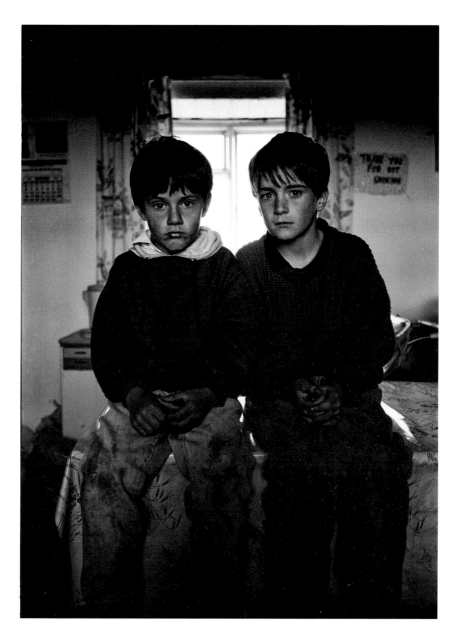

(L–r): Coleman King and Jason Prendergast, Low Road, Inishbofin

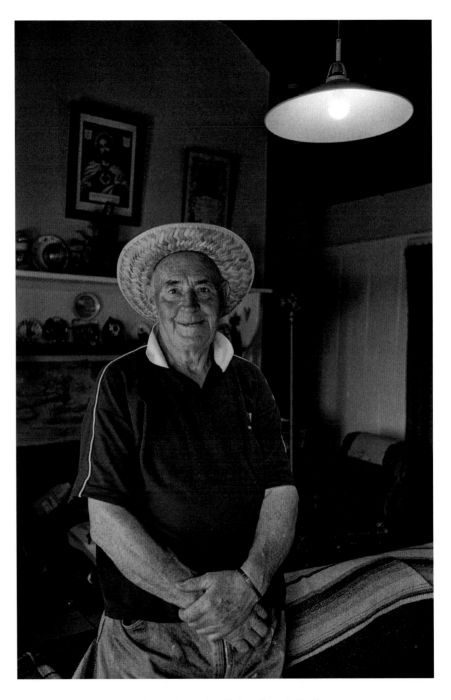

Festie McCann, North Beach, Inishbofin

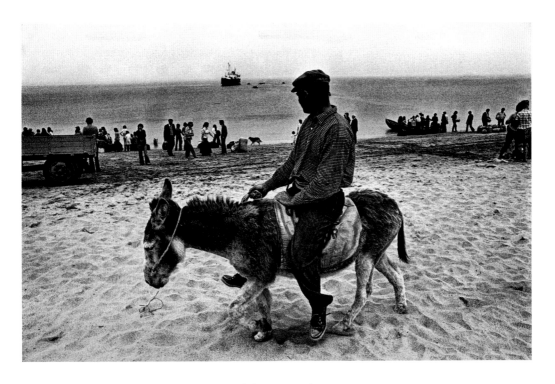

Observing the arrival and departure of visitors to Inis Oírr, Aran

Barbara Day, The Gáirdín, Inishbofin

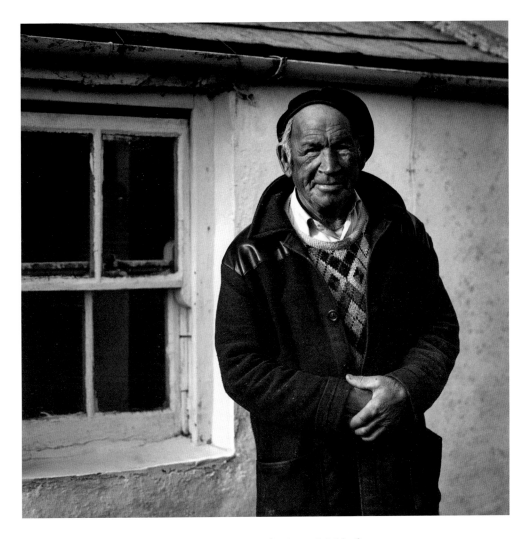

Jamesie Cunnane, The Bogs, Inishbofin

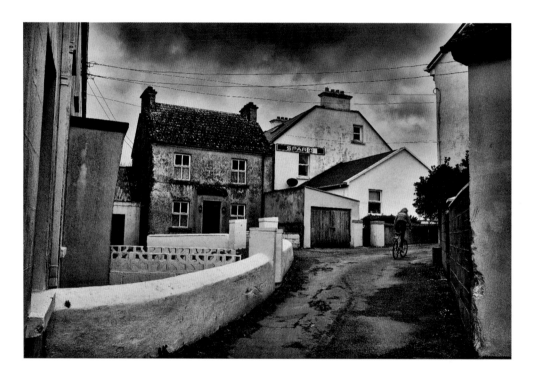

Kilronan, Inis Mór, Aran

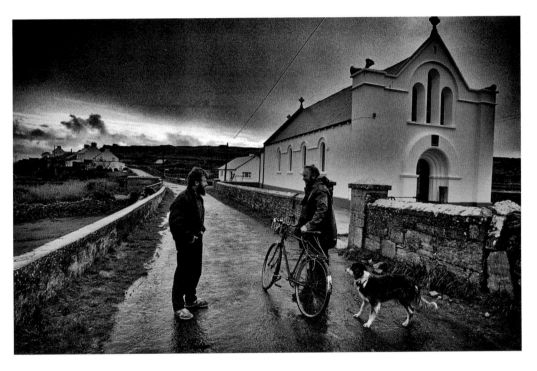

*(L-r): Fr Padraig Standún, author and former parish priest, and
Peadar Mór Ó Conghaile, Inis Meáin, Aran*

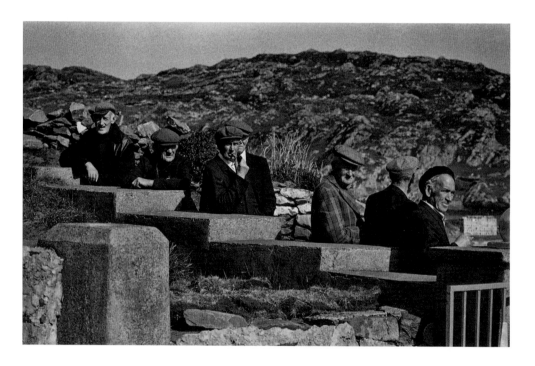

After Mass, Inishbofin

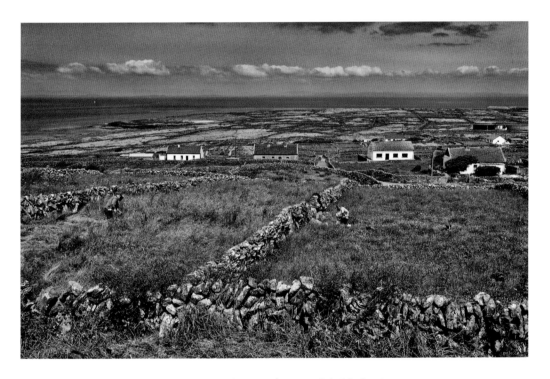

Farmers strimming meadows on Inis Meáin, Aran

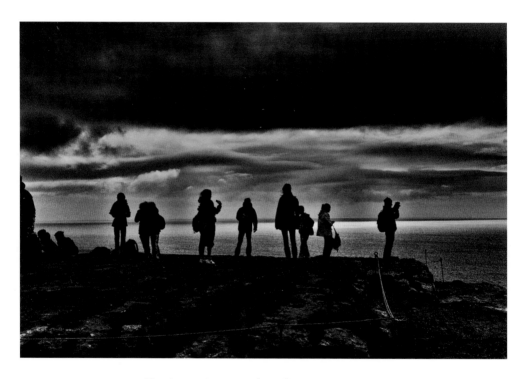

Tourists on Dún Aonghasa fort, Inis Mór, Aran

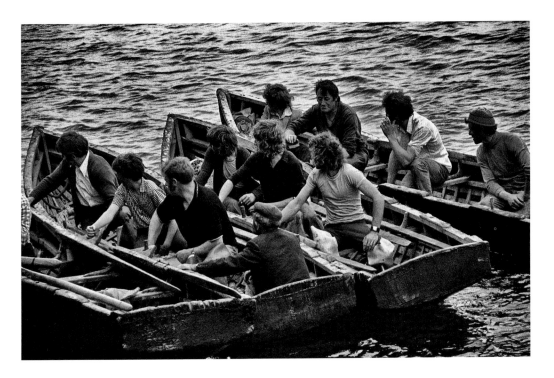

Aran men waiting for the ferry

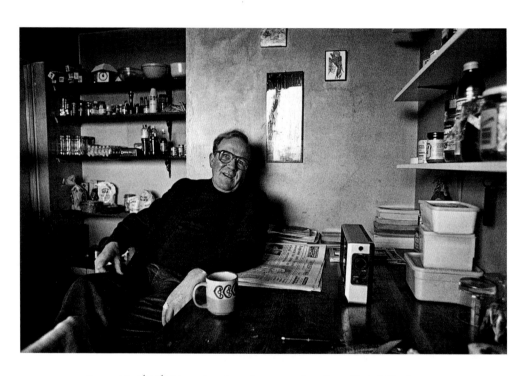

Breandán Ó hÉithir, writer, broadcaster and native of Inis Mór, Aran

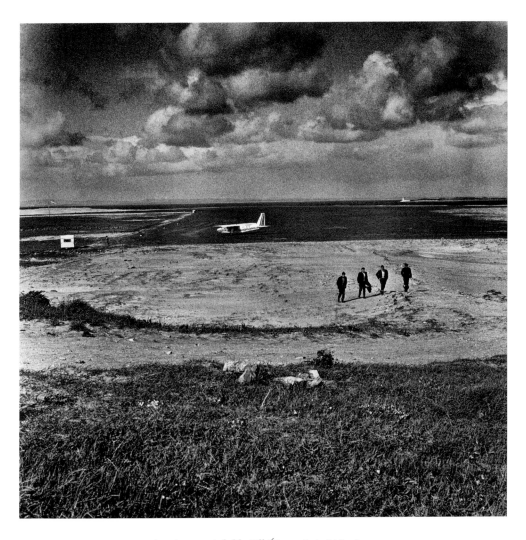

Aer Arann airfield, Cill Éinne, Inis Mór, Aran

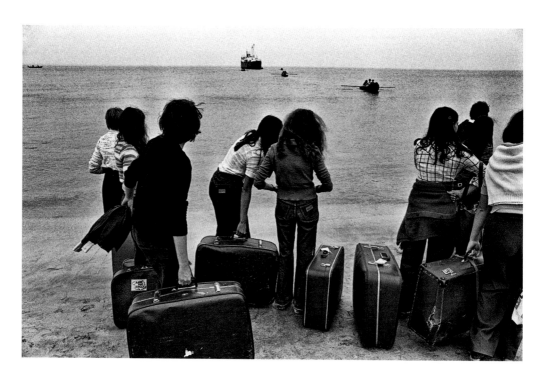

Gaelgóirí depart Inis Oírr, Aran, following their Irish-language studies

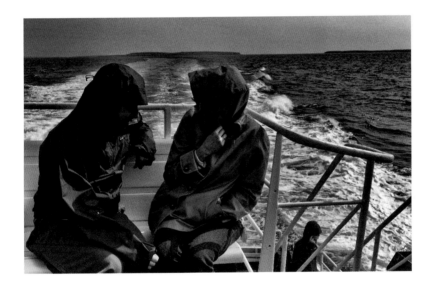

Leaving Inis Meáin, Aran

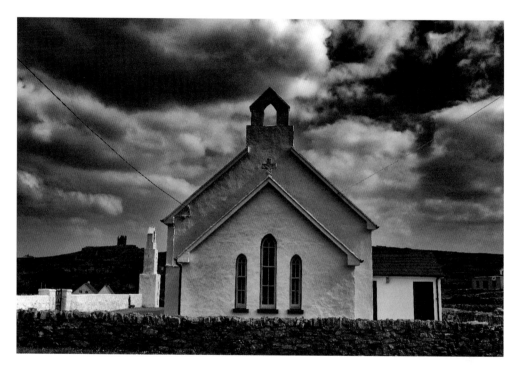

The church, Inis Oírr, Aran

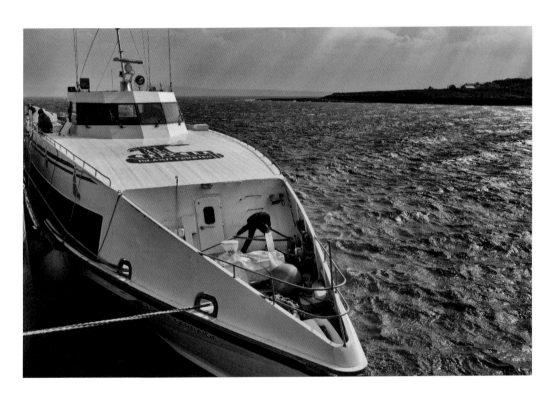

The Ceol na Farraige *('Music of the Sea') ferry docking at Inis Oírr, Aran*

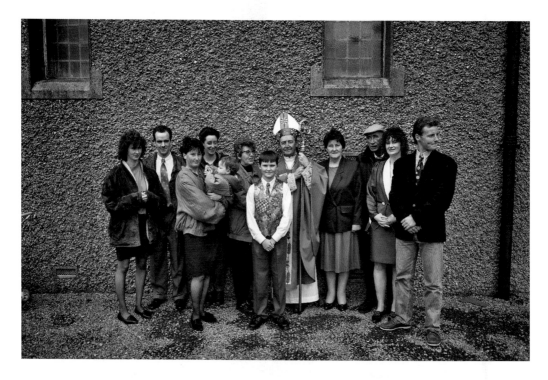

Dennis Burke on his Confirmation Day with his family and
Archbishop Joseph Cassidy, Inishbofin

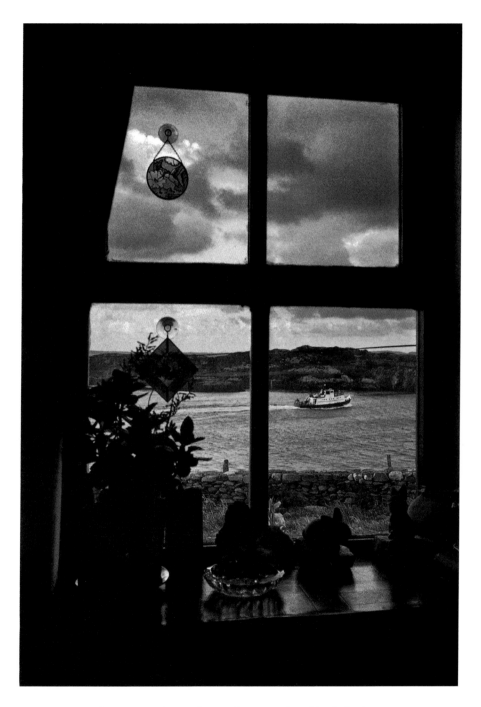

The Queen of Aran *ferry sailing out of Inishbofin harbour*

An Trá, Inis Oírr, Aran

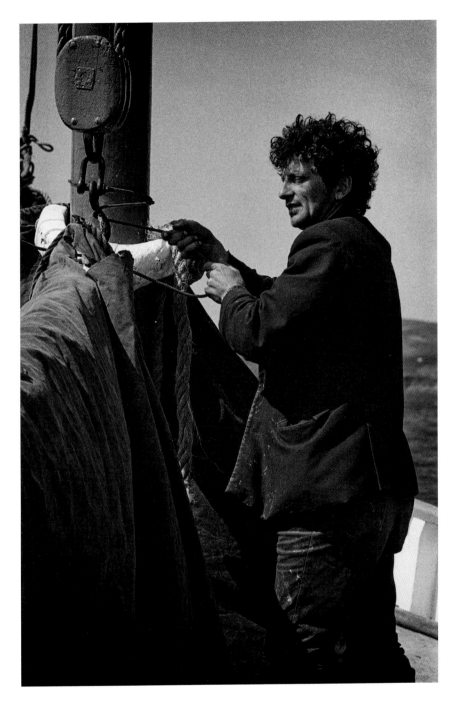

Paddy Joe O'Halloran sailing the Leenane Head, *Inishbofin*

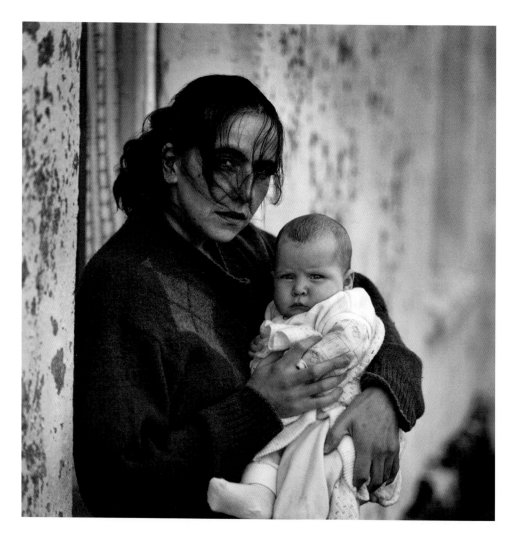

Mary Burke and her daughter, Aisling, Fawnmore, Inishbofin

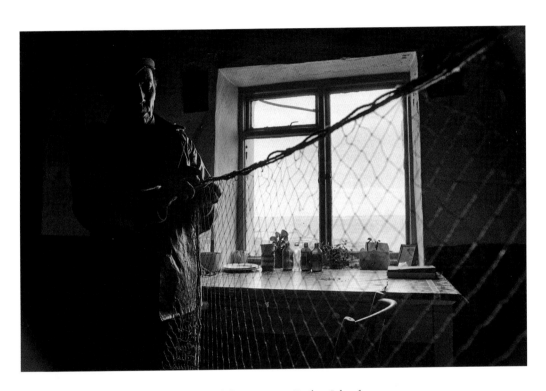

Mending fishing nets on Turbot Island

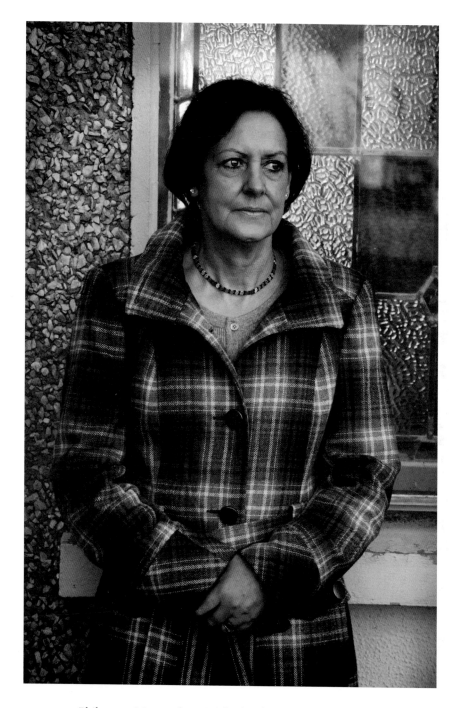

Philomena Murray, from Inishark, who now lives in England

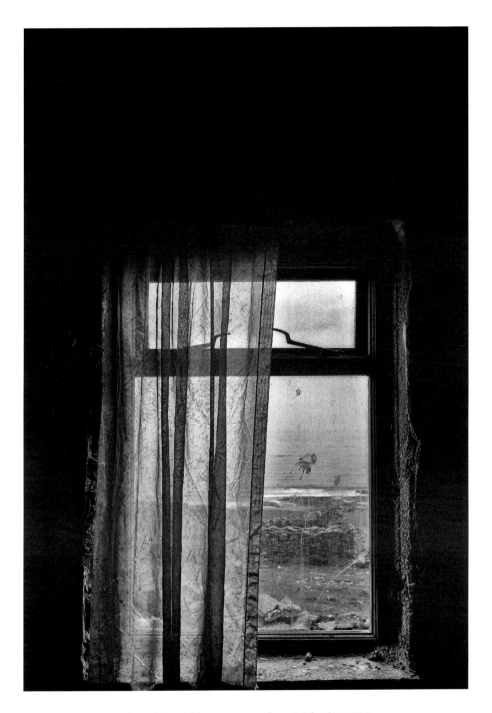

One of the old homes vacated on Inishark in 1960

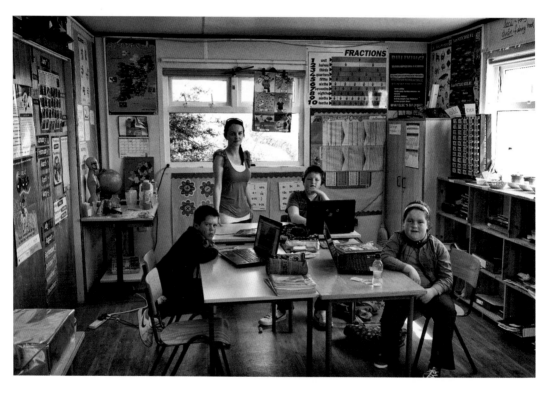

Theresa McGuigan, teacher, in her school on Inishturk, which comprises just three children (l–r):
Ryan, Nathan, and Katelyn Heanue

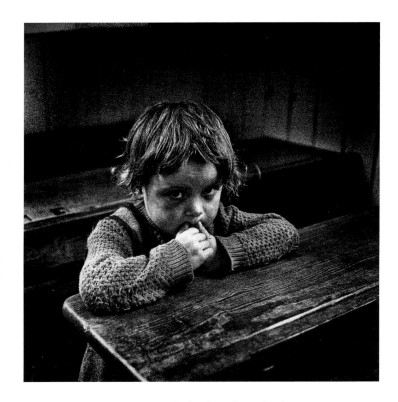

National school, Turbot Island

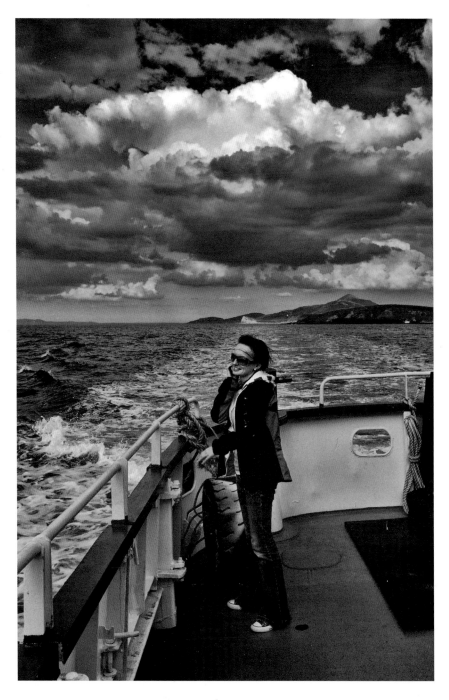

Theresa McGuigan sets sail for Inishturk from Roonagh Pier, with Croagh Patrick,
one of Ireland's sacred mountains, in the background